Jessica Hische

IN PROGRESS

See Inside *a* Lettering Artist's Sketchbook *and* Process, *from* Pencil *to* Vector

Preface by Louise Fili

CHRONICLE BOOKS

SAN FRANCISCO

10 9 8

Chronicle Books LLC

680 Second Street

San Francisco, CA 94107

www.chroniclebooks.com

 o all the teachers who helped mold my overly enthusiastic, pathologically optimistic younger self into someone able and excited to pass on knowledge to those who will follow my path. I am forever in your debt.

Contents

Preface

by Louise Fili

remember the day well. In 2006, I received a series of promotional cards for "The Twelve Days of Christmas."

The interesting style of illustration led me to take a look at the artist's website: hmm, nice lettering skills there, too. Who *was* this person? All I could discern was that she was a recent art school graduate living in Philadelphia. I sent an email asking to see her portfolio. No response. Undaunted, I contacted her former professors at Tyler. This time I got an immediate answer: My first email had landed in her spam folder, and she could come to New York the following month.

In a *month*, did you say? So I waited. When that momentous day arrived, I greeted Jessica Hische at the door of my studio. She was carrying a portfolio that easily weighed more than she; I couldn't help but notice that the shiny wrapping paper was a Hefty trash bag.

Before I even finished looking at her work, I offered her a job.

Two weeks later, she moved to New York and started working for me. At the time, I was designing the cover for a book about Paris patisseries.

Jessica, can you make this look like a grossgrain ribbon tied in a bow, with type on it?

Sure!

Next, a guidebook to shopping in Morocco: How about embroidering the type, with sequins?

No problem!

Can you make type look like this lace?

By then, I didn't even have to wait for an answer. I actually didn't even need to ask the question.

She was fearless. Two months after meeting Jessica, I promoted her to senior designer, and her boundless energy and abilities continued to amaze me. They still do. It has been a pleasure to watch Jessica bring her talents to a much larger stage (which is to say, the world) for all to see and enjoy.

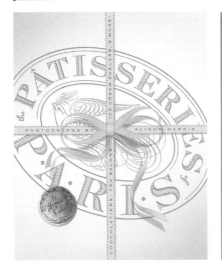

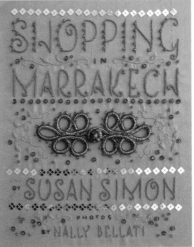

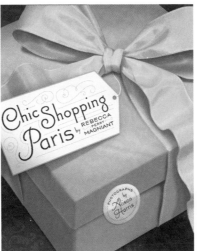

Above: Louise wearing my Halloween costume from 2008, when I dressed as a school portrait. She put up with my antics with perfect grace.

Left: Four of the book covers I worked on with Louise for her client The Little Bookroom. Below them is lacey typographic art we created for the *New York Times*.

Introduction

can't remember a time in my life when I wasn't driven to draw all day long. How I was going to make a career out of it, I had no idea; I didn't care.

The daughter of a dentist and a scientist-turned-housewife, I met shockingly little parental resistance while declaring my love for the arts and dreams of being a painter, poet, or ceramicist—whatever medium was moving me that week. I think my parents were just happy to have a well-behaved kid with a fairly inexpensive and supremely time-consuming hobby.

I was raised in a relatively rural part of Pennsylvania—Hazleton, to be precise —a town not historically known for being a center of arts and culture. It was a good-enough place to grow up, and it's given me a lifetime of small-town stories, most of which take place while loitering in various parking lots (Blockbuster, Walmart, Sheetz, etc.) or waitressing at the wonderfully horrible Greek diner I worked at in high school (the Blue Comet, lovingly referred to as the Blue Vomit).

While my childhood was happy and idyllic—involving a lot of corn mazes, sports injuries, coloring-contest awards, and overly sensitive reactions to teachers' criticism—my junior high to high school years were rocky to say the least. I think we all spend the entirety of our adult lives recovering from those few horribly awkward formative years. I became a bit of an academic underachiever, mostly because it's impossible to commit any serious time to your studies when every moment of every day is spent trying to be popular. I devoted my whole self to being socially accepted by the highly preened proto-teens but never quite made it in—I'd get invited to parties (a.k.a. drinking Zima and Jolly Ranchers in unsupervised basements) but would spend the night feeling uncomfortable and out of place. I rolled my uniform skirt perilously high, tried out for cheerleading (ending up on the gymnastically challenged outcast squad "The Freshman Five"), and skated by with "high-mediocre" grades in most of my classes. I was never a "bad kid"; I just wasn't the person you'd have ever nominated for "Most Likely to Succeed." Maybe I could have won "Most Likely to Not Be a Total Screw-Up" or "Somewhat Likely to Get It Together, Eventually."

This all might seem tangential or anecdotal, but I just want to make it clear that I was not always such a motivated and work-focused person. I never lost my

desire to pursue a creative career, but there was no possibility of doing so at Bishop Hafey High. Every attempt I made to steer my class schedule toward the arts was met with resistance. When I told the administration I wanted to go to art school, they told me I should instead take extra math classes, as those were more practical for college applications. The only art class I was able to take in my early high school years, led by a well-intentioned blues-guitar–playing former hippie, was populated by members of the football team looking for an easy *A*. I felt lost. Lost in both an institution devoid of artistic mentorship and my own fog of conflicting teenage emotions.

During this time, my parents separated and immediately transformed from "Mom and Dad"—divine, omniscient creatures—into normal human beings. It was a very tumultuous time that I won't describe in great detail because I love my parents and wouldn't want you to judge them for how they acted during their most difficult years (just as I hope you don't judge me for the nonsense I got into as a teenager). But I have to mention their divorce because it affected me so deeply. It started a fire in me—I needed to become independent as soon as possible, to find myself and my voice. The more intense the drama was at home, the more acutely I focused my attention back on school and on developing real friendships. In junior high I fought so hard to be "popular," to be included, but now I just wanted to be surrounded by people who accepted me for who I was—people whose main attribute was kindness.

In eleventh grade, I transferred to public school, and it felt as if things were finally on the up-and-up. I scraped together money from my after-school jobs, bought a 1994 Mazda Protegé for $2,500, and started dating a boy who was not only academically motivated (which in turn motivated me) but also kind and generous—a best-friend-turned-boyfriend. We showered each other with homemade gifts (he once made me a thousand tiny origami paper cranes for my birthday) and encouraged each others' artistic pursuits. I started regularly making art at a pace that I hadn't matched since early childhood. I made (terrible) paintings about my feelings and listened to the Smashing Pumpkins and Tori Amos on repeat. After years of being pushed in every direction but my chosen path, I pursued art with abandon.

I can't say I would ever want to live through those post–divorce teenage years again, but I'm thankful for them. I'm a different person because of them—more independent, more empathetic toward whatever secret hardships others have gone through (or are currently going through), and more in love with all the good parts of humanity. If you ever wonder why I seem to love people so much, to make endless Internet stranger friends, getting coffee with anyone who writes me a nice email, it's because of this time in my life. If you have a good heart, I want you around me forever and ever.

I had low expectations of what would come of my post–high school years. While I had a renewed drive to succeed and make art, I had only $5,000 saved for college and no hope for significant grants or scholarships. I took every art class I could in high school, but three semesters of passionate working didn't make up for all I'd missed in my messy earlier years. I had no artistic extracurriculars, and my portfolio consisted largely of tightly rendered still lifes of shoes. Still, it felt amazing to be surrounded by teachers who believed in and challenged me. I dreamed of attending RISD or SVA or any of the New York art schools but knew there was no way I'd get in, and even if I did, there was no chance in hell I'd be able to afford them. A representative from Keystone College came to our class to review portfolios and told me that mine was unacceptable, that it lacked the breadth of work they look for in applicants. My heart sunk into my stomach. If a local college, basically a step above community college, thought my portfolio unworthy of its program, I couldn't dream of applying to any of the more renowned art schools. For a semester I ignored what would become of my future and focused instead on just making as much art as I could. Somehow, I had faith that if I could just continually create work, my path would appear in front of me.

Carmina Cianciulli, the dean of admissions at the Tyler School of Art, came by for her annual inspection of portfolios in the fall of my senior year (Tyler, the BFA program at Temple University, recruited heavily from

larger Pennsylvania high schools because of Temple's low in-state tuition). She was kind and encouraging, giving feedback similar to that of the Keystone rep, but saw potential in me that he had not. Mrs. Angela Glowatch, my art teacher (whom I should really refer to as Saint Glowatch), sang my praises to Carmina. She told her I had talent but only recently had the opportunity to begin refining it—that Tyler was the perfect place for me to find my artistic voice. At that point, I would have gone anywhere that would have me. I couldn't believe it, but Carmina accepted my portfolio that day. I exploded in a fit of rainbow happiness and immediately sent in my full application to Temple.

I graduated from high school and in September found myself (in more ways than one) on Tyler's campus on the outskirts of Philadelphia. I had emerged from my teenage years and could start over, fresh and clean, at this new place. I never felt as though I could catch up to my peers in high school, who for years had been taking AP classes and college-prep courses, but in college I had the same opportunities as every other incoming freshman. Tyler, with its run-down campus in Elkins Park (they had been trying to move the school downtown to the main campus for over fifteen years and had put off reconstruction because of the "impending" move) and roughly one thousand total students was the setting of some of the best years of my life. It was a frenetic pool of not-quite-adults, pursuing all the best stereotypical art paths while living a creative adaptation of the typical college experience.

I threw myself headfirst into my classes. I had no idea what I wanted to major in because I loved every class I took, be it sculpture, painting, photography…anything. With all my enthusiasm there was still something holding me back—I was self-conscious about my fine art. After seeing the kind of work my peers had produced in high school, my mediocre, angsty abstract paintings embarrassed me. I was nineteen and felt as if my life wasn't interesting enough to produce interesting artwork—I was acutely aware of how limited my perspective and experiences up to that point had been. It was easy to find motivation to do class assignments

(color studies, figure drawings, etc.), but what would I do when school was over and I had to apply these skills to actual self-expressionistic artwork?

I took my first graphic design class in my sophomore year, and immediately the path in front of me, or at least the first few yards of it, became clear. It was so freeing to be able to make work that wasn't about me but about solving problems. If I had to represent my career visually, it would look like a constellation—a line, interrupted occasionally by bursts of energy that slightly or dramatically shift the direction of the path. Finding design was one of these bursts—an ah-ha moment, reaffirming all the decisions I had made up to that point. All the energy and momentum I had built up found an outlet through design. The work was addictive, and I couldn't get enough. When projects called for one poster, I made five. I took every opportunity to push projects further—I incorporated illustration and eventually hand-lettering (which, at the time, I had no idea was a career path unto itself) into my work. I would pay attention to which parts of projects I was devoting the most time to (which parts I was procrastiworking* on) and would take note, knowing that each of those moments might be another burst along my career constellation.

My junior and senior years were packed with a variety of design studio classes—packaging, identity, publishing, art direction—and endless all-nighters spent in the computer lab with my weary compatriots. Someone left a Postal Service CD in one of the labs, and it became the soundtrack for nearly all our senior year because we were too exhausted to remember to bring in something new. We made endless late-night trips to Wawa for shitty coffee and sandwiches. We made jokes about fonts and found them outrageously funny. It was terrible and amazing and perfect. As graduation approached, we scrambled to put the finishing touches on our portfolios—these giant black briefcases that would determine the course of our future.

I ended up graduating with the top portfolio in my class, despite the stiff competition that year. All those late nights in the lab, the 18-credit semesters, and the critiques that

occasionally incited tears felt worth it. I worked my ass off—harder than I've ever worked in my life—and I loved every minute of it. In those four years I fell so deeply in love with work but still somehow found time to fall in love with friends, a boy or two, midnight bike rides through the streets of Philadelphia, and indie rock shows at the First Unitarian Church. Work and life were seamlessly intertwined. Years later, I still try to keep it that way.

One of my professors in college, Paul Kepple, owns a small design shop in Philly, Headcase Design. Thanks to a bit of persistent asking after class, I became the studio's very first intern. When I graduated, that position transitioned into a full-time freelance gig. I loved working at Headcase for so many reasons. Paul is an amazingly talented and kind man who was an excellent early mentor. The studio was run out of his super-designy loft, and all the projects were fun and challenging. Headcase's work consisted mostly of design-heavy book projects and editorial illustration, giving me insight into two very different processes and growing my love for illustration. The studio designed the keepsake book for the Broadway musical *Wicked*, which brought in similar projects like *The Sopranos* commemorative book (I got to go on set! Uncle Junior put his glasses on my face!) and a book for the Broadway show *Avenue Q* (still have every song memorized). The studio was so small that I felt as though I was making real contributions to the projects, which was incredibly empowering.

After a few months, many of my classmates had left Philly to pursue jobs in other cities, and I made friends with a number of freelance illustrators in town. Seeing their lifestyles and how they worked (often working more hours than friends with "real jobs" but having completely flexible schedules and the freedom to work from home) showed me a route my career could take—I could and would work for myself some day. About six months into my full-time gig at Headcase, my hours were cut—Paul wasn't ready to commit to a third employee—and I started actively pursuing freelance illustration work.

That fall, I put together my first real promo: a postcard set of "The Twelve Days of Christmas," each day represented by a whimsical illustration on its own postcard. I had been helping artist rep Frank Sturges rework his website and wanted desperately to join his group of awesome illustrators, a few of whom I had befriended in Philly. I was young (twenty-two) and in no way had a body of work that was on par with other folks in his group, but when he saw my promo, something made him decide he wanted to take a chance on me (he later told me that he saw potential in me and was worried another rep would scoop me up). He gave me a list of 250 art directors at magazines and agencies to send my promo to, and I spent every last penny paying for professional printing and stamps, enlisting the help of friends (promising pizza compensation) to assemble them.

✳

Procrastiwork is a term I made up to describe the work that I do when I'm putting off the work I'm supposed to be doing. It originated from an interview I gave in 2008 on a website called Humble Pied—I was asked to give one piece of advice to other designers, and the advice I gave was, "The work you do while you're procrastinating is probably the work you should be doing for the rest of your life." I began noticing in college that, even though I loved all my classes, there were certain kinds of projects that I gravitated toward, and I would put off other assignments to work on them. Paying attention to my own procrastiworking habits helped me choose my major in college and helped guide me toward a career in lettering. I continue to procrastiwork all the time—sometimes on side projects, sometimes just on other client projects—and doing so, always trying to work on something that is exciting me in that moment, has really helped with productivity and motivation.

Aside from art directors, I also sent the promo to a few people whose work I admired, not because I expected to hear from them but just because I wanted to give them something for the inspiration they'd given me in college. One of those people was Louise Fili, a legendary designer whose beautiful vintage-inspired typography I deeply admired. After weeks of waiting for some sort of feedback from any of the promo's recipients, I received an email from the last person I thought would ever respond: Louise. She asked me to come in for an interview; a junior design position was opening up at her New York City studio. Immediately I was filled with both joy and intense anxiety. I had just gotten into a good groove with the little freelance work that was trickling in and I was teaching a class at Philadelphia University—I didn't dream of moving to New York and wasn't actively looking for a full-time job; I was trying to get my freelance career going. At the interview, she offered me a job, and I had to choose between my increasingly comfortable life in Philly and a new, exciting, and scary life in New York. It was clear that working for her was a tremendous opportunity, one that I couldn't possibly pass up, but it still was terrifying to uproot my life and move to a new place by myself.

In a few weeks I found myself in an apartment in Greenpoint, Brooklyn, with a Craigslist-scavenged roommate nearly fifteen years my senior, battling a chest cold and the loneliness of a New York winter. The job was amazing, but it took me a long time to warm up to the city and understand the dynamics of a New York friendship (which mostly involves assuming you're invited to things and not waiting to be invited). I befriended a few illustrators in Brooklyn (cold-emailing them when I first got there), and in no time they became my core friend group. Despite my awesome day job, I didn't want to give up my self-employment dream, so I freelanced at night, working almost every evening until 1 or 2 a.m. A number of my new friends had studios at the Pencil Factory (a converted Eberhard Faber factory full of artist studios), and I decided that having a separate work space, even one that I wasn't using full time, made more sense and

would be more fun than working from my tiny apartment. Few others worked late into the night as I did, but the hour or two of overlap that we shared between their day shift and my night shift was enough to propel my productivity through the evening. I worked every night and nearly every weekend, but I loved it. Because the work I was doing at night (illustration) was very different than the work I was doing during the day (design), it was relatively easy to stay motivated (I've continually found this to be true—if you vary the kind of work that you take on, or break up your work day in some way, it's easier to find the stamina and endurance to work around the clock).

I looked forward to going to work in the morning, to spending a full day learning from Louise, perusing her endless beautiful books and printed ephemera. It was one of the most influential periods of my life, and I owe Louise endless gratitude and pastries for all she taught me. During that time there was one project that made clear to me how insanely specific your work passions could be: We were working on packaging for a chocolate company and had to hire an illustrator to draw ingredients. I knew that illustration was a very broad field and that people specialized in children's books or conceptual editorial work and so on, but we were choosing from portfolios of artists who made their entire living drawing chocolate and other photorealistic foods. My mind was blown open. I was reading Malcolm Gladwell's *Outliers* at the time, and his ten-thousand-hours theory already resonated with me heavily. Seeing illustrators—real live people who were not so different from me—able to make a living specializing in one weird form of illustration was fascinating and very motivating. Up to that point I thought of lettering as being a thing that designers did from time to time to customize their projects, not something I could specialize in and fill my life with.

Lettering perfectly combined my favorite parts of illustration with my favorite parts of design. I enjoy the pace and scale of editorial illustration projects (usually fast, one-off pieces), and it's great to constantly work with other creatives and art directors. I could stare at beautiful typography all day while working on graphic design projects

and enjoy the variety of forms and styles the work can take depending on what's appropriate for the client or concept. Through lettering, I could work like an illustrator but use all the typographic skills I'd learned pursuing a career in design. I absolutely loved drawing custom logotypes and book titles for Louise and wanted to incorporate lettering into my freelance illustration work.

After about two years of working for Louise, my life felt a little out of control—my crazy work schedule was wearing on me—too much stress and too little sleep was translating into a constant stream of chest colds. I felt pressure to take on every incoming freelance job, fearing that eventually my busy streak would end and my freelance dream would never come to fruition. In the spring of 2009 I was putting together my taxes and was dumbfounded to discover that I had made twice my salary in freelance work—it was clear that I had enough momentum (and enough emergency funds in the bank) to go full-time freelance. Still, it wasn't easy to leave my job—I loved working for Louise, and we had grown close over those two years. It took me a few months to work up the courage to give notice. In September of 2009, my night job became my day job, and I've worked for myself ever since.

My new flexible schedule allowed me to work on side projects, one of which became the biggest burst on my career constellation: Daily Drop Cap. For the most part, people were hiring me to do representational illustration and only the occasional letter-laden project, and I wanted to make sure that I was lettering every single day, even when clients weren't paying me to do it. I didn't want my typographic muscles to atrophy—I had spent too much time training them while working for Louise. I gave myself a goal: I would draw one letter a day until I worked my way through twelve alphabets (choosing twelve because maybe I could make a calendar or something at the end of the project). I would work in whatever style I wished and begin each day by drawing an illustrative initial cap. I set up a Tumblr and got to work, posting a new letter I had drawn every day.

Over the next few weeks and months, something happened that I didn't expect: People were paying attention.

A lot of people were paying attention. Suddenly people wanted to interview me, and I started getting fan mail from young designers saying Daily Drop Cap inspired them to start their own daily creation projects. I was asked to speak about my work in front of university students and eventually in front of huge audiences at international design conferences. My little online following grew and grew. At its peak, Daily Drop Cap was getting over 100,000 unique visitors a month, a number that seemed unfathomable to me. Clients started to come to me specifically for lettering projects, and I was over the moon.

There have been a number of other self-authored side projects and client commissions that have pushed my career in one direction or another, but Daily Drop Cap gave me that first big burst of momentum after going out on my own. Now, years later, I still use side projects to fill in gaps in my portfolio, have fun and further develop my skills, exercise parts of my brain that aren't accessed through client work, and share knowledge that I've picked up over the course of my career with other creatives (such as in my Don't Fear the Internet site or my Should I Work for Free? flowchart). It's through these side projects and my endless oversharing on Twitter that I've been able to build up a community of wonderful, kind, and encouraging people around me.

Some creatives share much less of their personal lives with the world, but who I am and my experiences have everything to do with how I work and what kind of work I'm interested in doing. Through design, I found a way to be a part of an awesome, accepting community, and that's really why I've fallen so deeply in love with it. I want to give all the amazing and lovely people that I've met (or hope to meet) the opportunity to feel what I feel when working. I want to quicken their pulse, to make them giddy with excitement to pursue whatever it is that they love with abandon. I'm so lucky that I've found a way to do what I love every day, and I want to enable other people to do the same. Hopefully this book helps a few of you find a way to do (and hopefully get paid to do) whatever it is you want, and if not, at least there's a lot of pretty pictures.

The Typographic Arts

Lettering, Calligraphy & Type Design

In college, I had no idea what lettering was or that it was something I would end up doing as a career, but I think that's probably the story most people in niche industries have about how they discovered their offbeat passions.

We start off having a general idea of what we like (which, when we're young or inexperienced, already feels very specific) and as time passes, we fall deeper down the rabbit hole of our own interests. I like to compare the "finding your passion" process to discovering music—you begin by liking a broad category like "rock" or "folk," and in listening to a lot of artists within this broad category, you discover bands you like and subgenres you want to pay attention to. You listen to the most popular bands within those subgenres, pick your favorites, then follow them up their tree of influence until you find your niche. When you finally discover you have a passionate interest in Mongolian throat singing, the path to it seems so simple.

I should probably explain what the hell lettering is to folks that might group all typographic work into the same category. The world of letter makers can be broken into a few categories: calligraphers, letterers, and type designers. Calligraphers and letterers create custom artwork, while type designers create systems of letters ("typefaces") that must work in endless combinations, eventually output as a "font" (the software you install onto your computer). Calligraphers write words; letterers draw them. Calligraphers train their hands to utilize tools (different kinds of pens and brushes usually) in a way that is so perfect and consistent that when a client hires them to create fancy letters, they do it swiftly and expertly. Some calligraphers are very inventive, but generally they choose a few styles to master so when they are hired to output two hundred envelopes for a wedding, their muscle memory kicks in, the letters flowing out of their pens and brushes smoothly and confidently.

If you ever have the opportunity to take a calligraphy class or workshop, I highly (highly!) recommend it. Having an understanding of how different

1

Vector drawing is a form of computer-aided drawing that uses paths defined by anchor points rather than a series of dots (pixels). These paths can be used to create simple or complex drawings.

2

Anchor points are the basic components of a vector path (line/line segment). They occur at the beginning and end of a path and at any point where the direction of the path changes.

writing implements affect letterforms will improve your lettering, type design, and graphic design in general. I'm a terrible calligrapher, but I work in calligraphic styles a lot for my lettering projects, and every time I pick up a broad, pointed, or brush pen (see page 44), I have a eureka moment about how a letter should behave. Letterers can break all the rules if they wish—they can defy pen and brush logic and make crazy, zany letterforms not grounded in tradition—but, like many people have said before, you have to know the rules to know how to break them. If you understand calligraphy, you are better at critiquing your own lettering work. When something doesn't look quite right, you understand how to fix it—you realize it's because a thick pen or brush stroke would never happen on that side of the letter if you were using that tool, and so on.

Letterers work in many different media—some paint, some do tight technical drawings, some embroider. My medium of choice is a computer and vector drawing[1] software, and I draw my letters one anchor point[2] at a time. It's the medium

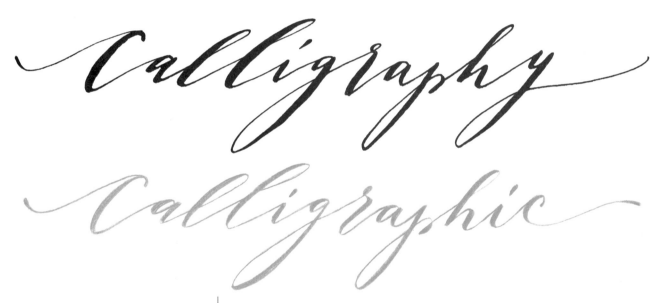

It can be difficult to tell the difference between calligraphy and calligraphic lettering or type design. There are a ton of calligraphic script fonts available, and letterers often work in calligraphic styles.

The top image shows calligraphy by Mara Zepeda and the bottom is pencil lettering by me (based very closely on Mara's work, created with permission just to illustrate this point). The creation process is what separates them.

more than anything that influences a letterer's portfolio—we work in many different typographic styles, and a consistent (or consistently inconsistent) medium unites the work. I love lettering because it combines my favorite things about illustration (working with other creatives more often than with the actual clients, shorter timelines, interesting and varied subject matter) with my favorite things about design (typography and the variety of styles and approaches to projects). As an illustrator, when you're commissioned to draw a fire truck, the client has a certain (and very specific) expectation for what that fire truck will look like. They've likely hired you because they saw another fire truck in your

Script

Blackletter

Serif

Sans Serif

"Crazy Circusy Wood Type"

portfolio and want you to draw them one just like it. As a letterer, you might be commissioned to draw the word *Love* over and over again by different clients, but each time, you get to draw it differently to match the article, book, or ad it's drawn for. You could draw it a hundred times and never repeat yourself, working in a variety of styles: scripts, blackletter, serif, sans serif, or crazy circusy wood-type styles.* Yes, you still do get hired to "play your greatest hits" from time to time, but even then, each time you make changes, you improve.

Type designers are basically crazy artist-engineers who toil for years making bits of software no one wants to pay for. Most people never realize that the typefaces they use every day were made by actual human beings, many of whom are alive and well and reachable by email. Type designers draw letters, but each of those letters has to interact perfectly with every other glyph in the typeface.

The font has to work as well on a brand-new Mac with up-to-date design software as it does on a crappy ten-year-old PC using "design software" as sophisticated as Microsoft Word. It has to be idiot-proof and future-proof. It has to account for the fact that no one really understands what their kerning[1] settings* should be in InDesign. Most people will never use the awesome OpenType features type designers spend weeks or months baking into their fonts, sending angry emails about how all the fancy swashy characters they were promised are nowhere to be found.** I dabble in type design but wouldn't call myself a type designer yet—I've made jokes with type nerds that I'm in the "Fuzzy Navel" stage of my typographic career, and eventually I'll be ready for "Single Malt Scotch," but until then, I'm happy lettering.

1

Kerning is the addition or removal of space between two individual letters while designing or setting type. Traditionally, to kern was to subtract space between two letters by removing some of the metal body of a piece of moveable type, leaving a "kern," or a bit of the letter itself overhanging the metal body.

❋

Good fonts have good kerning built in, so start with kerning set to Auto/Metrics (which keeps the type designer's kerning intact), not Optical (which erases the type designer's kerning and makes up new kerning) or Zero (which eliminates kerning entirely, using only the side bearings of the letterforms for spacing).

❋ ❋

FYI, you can enable available OpenType features in Illustrator or InDesign through the OpenType palette and find all the glyphs of the typeface you're using in the glyphs palette.

The Process

Creating Lettering: From Blank Page to Finished Art

ow that you have a better understanding of what lettering is, we can dive into how I actually make the things I make. Figuring out an artistic process that works for you is one of the best things artists can do to improve their work (and happiness).

We all have a set of steps that we run through to take projects from concept to finalized art. Favorite tools enable us to visualize our (or our clients') ideas, and favorite places to work set the mood to make all the magic happen. It takes a lot of self-awareness and a good amount of discipline to come up with a system that maximizes your abilities and minimizes your bad tendencies. Your process is something you continually refine your entire life—what worked for you at twenty-two might not work for you at fifty-two. It's always good to step back and look for pain points on your work-creation path to not only figure out how to be more efficient but also to evaluate what your favorite parts of your process are so you can do those more often. No matter how good you are at self-evaluating, asking your peers for help and criticism is incredibly important. Setting up a good productivity-enabling support network around you will motivate you more than you could ever imagine, and constructive criticism along with self-awareness is the pathway to personal growth.

I came to realize that sketching was an integral part of my process after all too often trying to work on final artwork before I had a solid concept in mind. It's tempting to jump onto a computer before taking time to actually figure out what it is you want to make (ask any graphic design professor, and they'll lament how this is their top issue with early design students), but I've found that doing so always leads to frustration, boring ideas, and a sameness to your work. It may take some figuring out, but once you break down your process into distinct stages with rough timelines for each, it will become a lot less intimidating to start projects and also a lot easier to manage your time, come up with price quotes for projects, and so on. The steps that I established for myself are straightforward: (1) research and brainstorm, (2) explore thumbnails, (3) sketch, and (4) create the final artwork (and, inevitably, (5) revise). But it's the pacing of them that was key for me. It took time to figure out how long to spend researching and what kind of research I should do, how to pull ideas from that research, and how to translate those ideas into something a client would understand and get enthusiastic about. What works for me may not work for you, but I do hope that the insight that I can give you into my process helps you on your path to figuring out your best processes and ultimately makes you a mega-efficient super-artist.

The Tools:
Analog

My final artwork is digital, but much of my process happens off the computer.

There's a lot I love about sketching, but one of my favorite things is the portability of it. Yes, I could work on a laptop in most coffee shops, but when you're sketching, you can work anywhere—on a park blanket, in a cozy bar with a cocktail on hand, at a restaurant while having solo-dinner/me time—anywhere. All you need is a decent sketchbook and a well-curated pencil case.

I've tried several awesome digital sketching apps and devices and always come back to my simple analog tools. I love drawing by hand—it makes me feel connected to my little-kid self and realize that I actually get paid to draw for a living (which sounds crazy whenever I say it out loud!). Here are a few of the tools that I've personally found indispensable, along with some suggested tools to keep around the office for rainy-day experimentation.

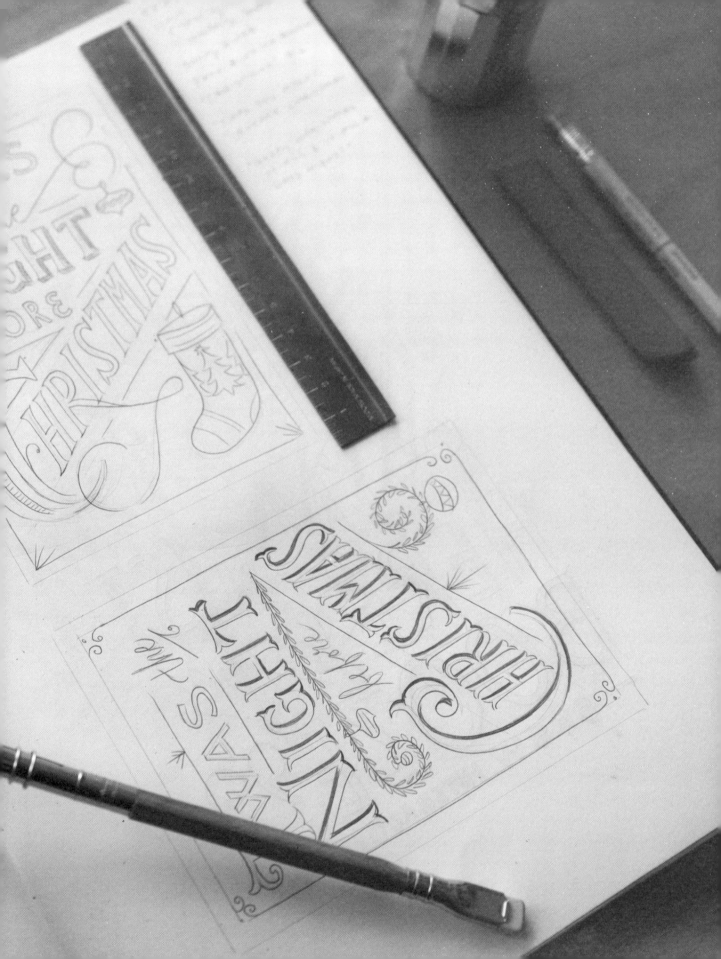

1. A hard-cover sketchbook

I'm currently using a sketchbook by Fabio Ricci that's about 8 by 10 inches—this is about as small as I'll go when it comes to sketchbooks. Moleskine and other small notebooks are great, but I have such a hard time sketching in tiny books. Another favorite brand, Leuchtturm1917, makes a variety of sketchbooks, and I prefer their larger books that are about 9 by 12 inches. What's neat about the Leuchtturm books is that they come with a sheet of paper with a grid on one side and a ruled paper template on the other, which allows you to turn your blank pages into gridded or lined pages simply by slipping this sheet behind the page you're working on. You can make your own DIY version of these handy sheets by creating different grid patterns in Illustrator and printing them out yourself. Then you can buy whatever brand of sketchbook you please!

2. A single sheet of dark cover-weight paper

The sketchbooks I use have relatively thin paper (compared to the very thick paper of a Moleskine sketchbook), which means that if I draw on both sides of every sheet, the previous page's design can be seen through the page I'm currently working on. If I put a sheet of dark paper behind that page (cut to the size of my sketchbook), it not only keeps the drawing on the backside from showing through (important while I'm working or while I'm scanning or photographing sketches), but also prevents me from accidentally carbon-copying previous sketches on top of each other. Try it out; it's one of those little creative magic tricks that makes you ooh and aah when you see it in use.

3. Tracing paper

Every now and then I work on a project for which a lot of iterating is necessary. Rather than clutter my sketchbook with twenty pages of the word *gasp* written in every style imaginable, I'll use tracing paper or other cheap unbound paper (even regular ol' white printer paper works great). There's something about sketching inside a book that feels so permanent and serious; drawing on scrap paper keeps me from caring too much about the marks I'm making so that I can experiment more freely. I recommend that if you think one "bad" drawing "ruins" your sketchbook, do your sketches on loose-leaf or tracing paper and forego a sketchbook entirely. My studiomate in San Francisco, Erik Marinovich, works entirely on tracing and loose-leaf paper so that he can iterate to his heart's content.

4. A Small "Jotting Stuff Down" Notebook

I always keep a little Field Notes book on my desk when I'm working so that I can take quick notes, make to-do lists, and keep track of art direction communicated to me in phone calls. I definitely don't treat these guys as precious objects and I toss them when they're full.

5. A Small "Ideas" Notebook

I have a Postalco notebook (a small one, spiral-bound from the top with gridded paper) that I've had for a couple of years and keep in my bag in case I have an idea to jot down while I'm out and about. When I'm alone, I use my phone to document ideas for new projects, but when I'm out to dinner with folks (or even out by myself) whipping out my tiny notebook to take analog notes feels less rude than diving into my phone for a few minutes to document my thoughts digitally. I treat this notebook very differently than my Field Notes books, using it only for ideas and not random life notes.

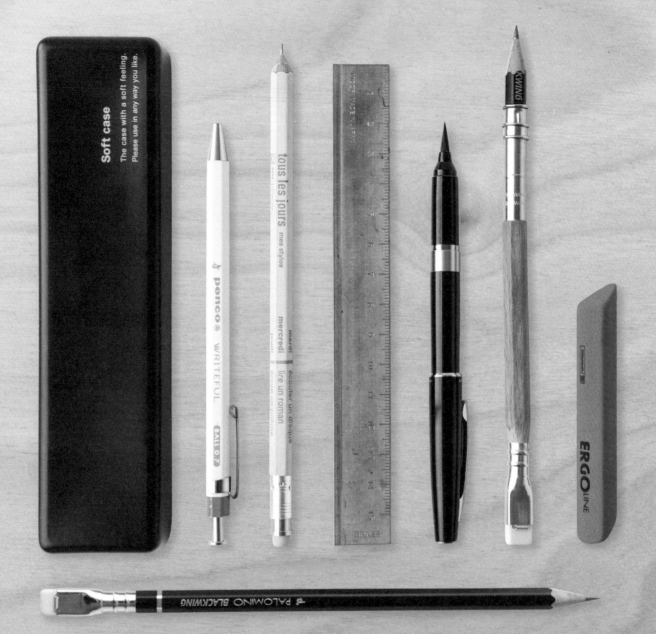

6. Pencil Case

Everything that you see above is what's inside my pencil case. For years I worked
without a proper pencil case, restricting my sketching while traveling to whatever
could be done with a cheap technical pencil, but now I'm totally hooked on
having my full analog arsenal with me 24/7. I use a soft plastic case that has
just enough room for the bare essentials—I leave all my crazy experimental
pens at my office.

7. 6-inch Ruler

A 6-inch (or 10-centimeter) ruler is the perfect size for drawing guides before you begin a sketch, and it fits nicely inside a pencil case! I have a little brass metric ruler that I love.

8. Blackwing Pencil

These pencils are great. The lead is very soft and smooth, which means you can make nice strong dark marks and also add shading to sketches quickly. They also have a pretty badass rectangular eraser. There are a few versions with different lead densities; I prefer the black pencils, which have the softest lead.

9. Pencil Extender

Instead of throwing pencils away when they get too short to handle, I use a pencil extender. They're usually wood and metal, and whenever you use one, you feel like a real pro. I whittled the end of mine so I can pop the Blackwing eraser on it.

10. Eraser

Sometimes you have a lot of erasing to do. Rather than wear down my pencil's small eraser in one session, I use a larger eraser. I really like Paper Mate White Pearl erasers, but it might just be because the monoline script they use is so fun and reminds me of those classic Pink Pearl erasers from childhood. I also have a Brunnen ERGO Line eraser that, I admit, I bought only because it's my favorite color (warm orangy red).

11. Technical Pencil

I used to do sketches entirely with technical pencils until I rediscovered the amazingness of soft-leaded pencils. Now I mostly use them for laying down guides and doing "under-sketching" of layouts and lettering when I begin a drawing. I love the cheap Bic technical pencils you can buy in a big pack, but occasionally I'll splurge on a fancy one if I encounter a cool stationery store. My current fancy technical pencil is French Days Tous les Jours wooden pencil by Mark's Inc., which I bought entirely for superficial reasons (they come in fun, bright colors and look very stylish).

12. Black Ballpoint Pen

For note taking, I tend to prefer pens with a more restricted ink flow, like the Penco Writeful pen I picked up recently. I was definitely the kid with ink smeared all along her writing hand and whose pen exploded in her mouth midtest, so I steer clear of pens that output a lot of ink. I used to love using Micron pens, but because I press so hard when writing, I tend to ruin their tips quickly, so a ballpoint pen works great for me!

13. Brush Pen

Brush pens are great for experimenting with brush-lettering styles, and I always keep one handy in my pencil case. I have a really beautiful Pentel brush pen that has refill cartridges, making it perfectly portable. Regular brushes and ink allow for a greater variety of styles and happy accidents but are way less portable.

14. Pencil Sharpener

A good sharpener is necessary if you're using traditional pencils, and I prefer manual sharpeners to their efficient electric brethren (also, as a frequent traveler, I would look ridiculous using an electric pencil sharpener on a plane). Sharpeners that have a container for pencil shavings are great so your desk doesn't end up covered in graphite dust, and they're perfectly portable. I have two favorite sharpeners: a Dux Glassware Inkwell Sharpener (which has a pretty blue glass base) and a faceted cylindrical metal sharpener, also by Dux, that leaves a neat light reflection on my desk.

15. Parallel Pens

Parallel pens work like broad-nib calligraphy pens and are perfect for emulating a broad pen style or working with blackletter. I use these guys sparingly or just when experimenting with calligraphic styles. Pilot makes a few versions with different nib (pen tip) sizes.

16. Pointed Pens

These traditional calligraphic pens are fun to play with but are definitely tricky. I'm always impressed with artists who can work masterfully with pointed pens and create beautiful copperplate scripts and calligraphic ornaments. I mostly use them to experiment.

17. Scotch Tape

Print out your lettering or type with a laser printer, wrap Scotch tape around your finger, and tap-tap-tap the ink away in little bits. The end result is unpredictable, which is how you want it to be! It's better for distressing type than any downloadable texture or Photoshop trick! (You can also use an X-Acto blade to scrape around the outer edges of letterforms to make their silhouettes less crisp, or crumple up your laser printout into a little ball, then flatten it back out, which gives the toner a crinkly, distressed effect.)

The Tools:
Digital

1

Bézier curves are the curved segments of a
vector path. They are defined by math equa-
tions (which, thankfully, Adobe Illustrator
handles for us).

ll my final artwork is created digitally, anchor point
by anchor point, usually in Adobe Illustrator or
font-making software like RoboFont.

I certainly didn't set out to be a "digital artist" (a term that sounds dated and
awful) when I applied to art school, but the process of vector drawing fascinated
me, and I found that while endlessly tweaking Bézier curves I entered a total flow
state—hours could go by, the album would end, the sun would go down, all without
me noticing. As much as I love to draw by hand, I think my art career would've
been cut short by carpal tunnel if I were drawing by hand all the time. (Over the
course of my life I've somehow unlearned how to hold a pencil/pen appropriately.
I hold it like a child holds a crayon, in a fist so tight I make marks on my palm
with my fingernails). By using the computer as a drawing tool, I break up my day
and prevent repetitive stress injuries. Carpal tunnel is, after all, caused by doing
the same thing over and over again, so mixing up my work and using different
media for different parts of my process keeps my wrists and fingers happy.

With good vector-drawing programs and a decent tech setup, I can make the
artwork that I want to make—artwork that is still "handmade" but cleaner and
more precise than anything I can make with analog art supplies. Plus clients love
that these types of files are endlessly scaleable (unlike pixel-based programs like
Photoshop). It's also easier to make changes even late in the creation process
(changing the color of something in Illustrator is a walk in the park compared to
changing it in an oil painting).

Technology becomes obsolete so quickly, but most of what is listed here will be
around for quite some time in one form or another. If you're a Windows enthusiast,
forgive me for being such an obvious Apple disciple, but their hardware is the
creative-industry standard.

1. MacBook Pro + Extra Display

I used to use a big iMac at my office, but managing multiple machines (a laptop for home and travel and a desktop at work) became annoying after my calendar became overrun with work-related travel. Even when using Dropbox or another cloud-based backup system, staying organized on two machines (and on top of software updates) is tough. I've found that the best solution for me is a tricked-out laptop (with a proper 15-inch display so it doesn't kill my eyesight when I'm on the road) and a larger external display (kept at my office)

2. Apple Wireless Keyboard

The laptop's keyboard is great when I'm traveling, but when I'm at the office I need a separate keyboard. I love the Apple wireless keyboard because it keeps my desk looking tidy and gets the job done.

3. Wacom Intuos Medium

I think Wacom digital pens and tablets are wonderful devices, but they are definitely better in more painterly programs like Photoshop than they are in precision vector programs like Adobe Illustrator. I use one at my office but don't necessarily prefer it over a mouse or the trackpad on my laptop, unless I'm editing or coloring sketches (and then I love it). Hilariously, I mostly use it on vector work when my mouse batteries are dead, which, truthfully, is most of the time.

4. A Solid-State External Hard Drive

I have an external hard drive that is locked to my desk (literally locked to my desk, in case our office gets broken into!) which I use to backup my laptop. If my machine has a meltdown, I know that not only is my work backed up but also I can easily get a new machine up and running without too much downtime. I recommend a solid-state drive because they're less likely to fail, as they have no moving mechanical components.

5. Smartphone

I hate to say I couldn't live without my iPhone, but it's kind of the truth. Don't get me wrong, I'm not a total smartphone addict (I am one of those people who leaves the house with 4 percent battery left on their phone all the time), but it sure does come in handy. I of course use it to do all the normal things people do, like manage email, tweet, whatever, but my phone has also become my scanner, thanks to awesome scanning apps that I'll talk about in a bit.

6. Kindle Paperwhite

Whenever I'm reading for pleasure, I read physical books (I love going into local bookstores and agonizing over the next book I should read or bugging the store clerk for recommendations), but when I'm reading for work I use my Kindle, mostly because of the portability (I'm often working on several book covers at a time and therefore have to be reading several books simultaneously).

7. Laser Printer

A laser printer is one of the most important tools you can have in your arsenal as a letterer. It's so much easier to criticize your own work when looking at printouts rather than the screen. There's something about seeing your work printed out that makes you notice things more...there's a permanence to it. When I was in high school or college and had a term paper due, it didn't matter how many times I reread it, ran the spell-checker, had friends read through it, etc.—if I didn't print it out, I'd never catch the two repeated words next to each other. I love to print out my work, mark it up, and make changes based on my markup criticism, behaving as though I'm my own harsh client. Look for a printer with a resolution of 1200 dpi or higher. There is no need to get an expensive color laser; black and white is the best!

8. Inkjet Printer

I have a big Epson Stylus Pro 3800 color inkjet printer for when I want to do test prints of posters or see final artwork at size in front of me before I ship it off to the client. I'd recommend that if you get a color inkjet for your office, get one that has all the ink colors (cyan, magenta, yellow, and black) as separate cartridges (like the larger-format Epson printers): You'll save a lot of money in the long run because you'll run through ink less quickly.

9. Good Camera + Tripod

If you want to shoot your own work for your website, I'd invest in a good DSLR. I love my Canon EOS 5D Mark II, and the lens I use most for shooting my work is a Tamron SP 24-70mm lens. There's a much more expensive Canon version of the same lens, but the Tamron is great and it has image stabilization, so you don't even need a tripod all the time! I've also used my camera to record videos of myself sketching for clients or presentations, speeding up the process for a time-lapse-esque look.

Software + Services

1. Adobe Creative Cloud

Nearly every designer uses Adobe products, and the programs that I use most are Illustrator, Photoshop, Lightroom, and InDesign. Illustrator is the vector software I use for drawing, I use Photoshop to manipulate and colorize sketches, Lightroom is great for making your photography look professional (I use it a lot to improve shots of my work), and this here book was laid out in InDesign! (I also use InDesign for contracts, invoices, etc.)

2. RoboFont

The typeface design software that I currently use is RoboFont, though other options exist. I had given Glyphs a whirl when it first launched and didn't find it very intuitive, but apparently it's evolved into a very good option and is less costly than RoboFont.

3. Reminders

I use the Apple Reminders program to create short-term and long-term to-do lists. There are a million to-do list apps available, and people will get into entirely-too-passionate conversations with you about their favorites, but I'm fine with the native Reminders. I use digital to-do lists to wrangle my inbox into submission—instead of letting an email fester in my inbox because I'm too busy to immediately address it, I add it as a task list item and let the sender know I'll be reviewing their request shortly. This way, I'm able to respond immediately even if I don't know the answer to their question yet! I have a number of lists set up that help me manage upcoming tasks:

Open Invoices: If I've invoiced a client (or need to invoice a client) I add them to this list, and once their invoice has been paid, I can check them off.

Code Fixes: When people email me that they've found a bug on my website, I add it to this list so that I don't go into an immediate panic and spend hours that day fixing something on my site. If it's a glaring error that I'm getting a lot of reports about, I'll attend to it swiftly; if not, I'll wait for a rainy day and plow through a bunch of fixes at once.

Speaking Requests: I usually can't give an immediate yes or no when a speaking request hits my inbox, no matter how awesome it sounds. I need to take a look at my calendar to see if there are any conflicts, be they personal or client-related. I set aside time every week or two to go over incoming speaking requests to see which I can take on. The average designer might not need a "Speaking Requests" list, but would probably benefit from a similar "Response Needed Soon" list.

Incoming Jobs: If I get an email from a potential client but no deadline dates are set in stone, I'll add them to the incoming-jobs list so I make sure I don't overbook myself in case the job becomes a reality.

Make a Print: I have a list of phrases I eventually want to draw and keep track of them here.

Meet Ups: When people let me know they live near me and would love to meet up for coffee sometime (and I can't immediately do so because I'm too busy or out of town) I add them to this list in hopes I can eventually make good on their invitation.

To Do Soon: This is stuff that needs to happen in the immediate future (within a week) and gets updated regularly. Usually things like "DMV renewal" or "email so and so about X." If I have a lot to do in a day, I usually make a hand-written to-do list of what needs to be accomplished by the end of the day. There's something about physically crossing things off a paper list that calms me down when my day is very hectic.

To Do Eventually: This is a bit of a catchall list for things like collaborative projects (if I receive an open invitation to collaborate with someone, I'll add it here if it's not time sensitive).

4. Apple Calendar + Google Calendars

I live and die by my calendars. I have several Google calendars set up to help me manage my life and business. These are then all pulled into Apple's desktop calendar.

Finals: Highlighted in red, this one lets me see obvious important final art deadlines quickly. (shared with my rep)

Sketches: I separate my sketch deadlines from final deadlines because sketch deadlines are usually a little flexible. (shared with my rep)

Meetings/Calls: This calendar covers everything from a quick client phone call to student portfolio reviews, in-person drinks with a client or colleague, podcast interviews...basically anything where I'm "working" but not drawing. (shared with my rep)

Life Stuff: For all the fun social events in my life. (shared with Russ, my husband)

Travel: To block off time that I'll be away from my desk, whether it's for a conference or personal. (shared with Russ and my rep)

Ultra-Schedule: I put together a calendar blocking off my time for the week into regularly scheduled repeating events so that I can get a better handle on my day-to-day work activities. For example, from 9 to 10 a.m. each morning, I answer email and following that have a long period of Internet-free work time before lunch. As a freelancer (and as someone who receives a lot of emails) it can be difficult to stay on task, stay off social media, and stop continually refreshing my inbox. My "Ultra-Schedule" calendar is usually hidden, but I turn it on when I find myself distracted so I know what I'm supposed to be doing that hour.

5. Skype

I have a personal Skype account and a separate account that I use for interviews and portfolio reviews, which allows me to keep my contact list under control.

6. Dropbox

Every single client project I've ever made is backed up on Dropbox. My external drive is a great backup option, but in case there is a fire at the studio or suddenly I have a technological apocalypse and all my hard drives die at once, I know I'll be covered.

7. Twitter / Instagram / Facebook

I use all three services a bit differently. Twitter is my primary work-related social network, though I treat it like a chatroom and most of my posts have nothing to do with work. On all three platforms, I try to be myself as much as possible, posting stream of consciousness thoughts, personal photos, pictures of in-progress work, etc. While tons of strangers follow me on Twitter and Instagram, I keep Facebook a private place for close friends and family.

8. SignNow or DocuSign

I get so angry when clients make me sign physical documents any more because these services are just so fantastic and easy.

9. Pinterest

I love it when clients put together secret inspiration boards for me at the start of a project—we get on the same page quickly, and any ambiguous art direction is immediately clarified. I use Pinterest for visual bookmarking (gathering inspirational imagery like vintage lettering, patterns, photography, color palettes, and so on), but find that I do more casual browsing/visual bookmarking on my phone or iPad (using the Pinterest app) than I do at my desk.

10. Scanner Pro

This is one of my favorite app store purchases I've ever made. You take a picture of a sketch or document, and the app detects the page edges and adjusts for distortion while also converting it to a black-and-white document with near-perfect levels adjustment. It's not the only scanner app out there, but it's served me well.

Research & Brainstorming

esearch and brainstorming are enormously important parts of the creative process. People often ask me where I find my inspiration for projects, and I can tell them confidently that what inspires my work the most is the content for which I'm designing.

I read every book (or at least a big chunk of every book) that I design a cover for, I read the articles I illustrate visual accompaniments for, and I research and get to know every client for whom I create a logotype. For example, when designing the book covers for the Penguin Drop Caps series (see page 100), I didn't have to look any further than the content to know what I wanted each design to look like. Each cover consists of only one giant letter—the first initial of the author's last name—and that letter needed to somehow represent what the reader was about to dive into. For William Golding's *Lord of the Flies*, the *G* took on the shape of Piggy's smashed glasses. For John O'Hara's *BUtterfield 8*, the *O* became the peephole of a speakeasy.

Proper research alleviates a lot of anxiety at the start of a project—the more confident you are in your understanding of the subject matter, the less worried you will be about your ability to come up with solid concepts. If you know your content well, you'll be less likely to use inappropriate visual references (you might fall in love with a fancy bit of vintage lettering on Pinterest, but it won't be an apropos starting point for every project). It's through this research that the primordial ooze of ideas is formed—an ooze that will eventually evolve into concepts through brainstorming.

Visual research is something that should be a part of your day-to-day life, not just something that you do at the start of a project. Be a sponge; absorb everything around you. Read books that have nothing to do with design and lettering, visit art and science museums, pay attention to fashion, stop to admire interesting graffiti or amateur sign painting. By living our lives and growing not only as designers but also as people, we amass a lifetime of inspiration that we can pull from consciously or unconsciously.

Sometimes you need to do more direct visual research for a project. For

instance, if you were making a poster for an art nouveau exhibition, you should look at original posters from that era. I highly recommend that when you have to do this kind of research you make sure you leave a bit of a buffer between your time spent researching and your time spent brainstorming. I notice that when I try to cram both processes into the same work session, all the information I've taken in through research hasn't had enough time to settle in my mind. I end up accidentally ripping off my source material or being too literal with my concepts.

Once I've absorbed as much as I can about the project and let it coagulate for a night or two, I sit down for a brainstorming session. Brainstorming, for me, is best done in the morning with a calm mind, a belly full of breakfast, and a coffee at the ready. I put pen to paper in my sketchbook or another notebook and let the ink flow freely, making word-association lists and writing down anything that comes to mind, no matter how outrageous, off-topic, or specific it may seem. You never know what will spark a great concept later. I don't make pretty mind-maps. The less attractive and organized this list is, the more likely I am to actually let my mind wander. Before I started integrating nonvisual brainstorming (the word-association lists) into the way I work, I found new projects incredibly intimidating—I'd stare at the blank white paper in my sketchbook knowing that, somehow, three distinct sketches needed to pour out of my head, through my pencil, and onto the page.

When my list is complete (usually after an hour or two) and I've exhausted all my brainpower, I scan the page for obvious ideas. Sometimes "obvious" works conceptually, but usually I try to dig a little deeper. Perhaps the combination of two obvious words yields something fresh and new. Maybe combining something more generic with something specific to my own experience will turn into a unique idea. By the end, I usually have at least a few ideas worth exploring visually, and I narrow it down to the best three to present to the client.

CHRISTMAS
TREE
ORNAMENTS
HOLLY
TINSEL
DOVES
ANGEL
TREE SKIRT
EGGNOG
CHAMPAGNE
BRANDY
WINE
MULLED WINE
HOT CIDER
HOT CHOCOLATE
12 DAYS OF XMAS
MISTLETOE
PRESENTS
TRAIN SET
SANTA
REINDEER
ELVES
WREATH
EVERGREEN
GARLAND
FAIRY LIGHTS
SNOW MEN
SNOWFLAKES
STOCKINGS
RIBBON
PETS
PUPPY IN BOX
COLD WEATHER
SNOW GLOBE
MUSIC BOX
HAM
FISHES DINNER
FRUITCAKE
SILVER & GOLD
BOWS
STARS
GINGERBREAD HOUSE
CANDY CANE

NEW YEARS
GLITTER
COUNTDOWN
BALL DROP
TOAST
MIDNIGHT KISS
BOOZE
DANCING
YEAR
YEAR GLASSES
PARTY HATS
NOISE MAKERS
FIRE WORKS
SILVER
CONFETTI

RUDOLPH
WISEMEN
NATIVITY SCENE
SLEIGH
SLEIGH BELLS
BELLS (GENERAL)
CAROLS
HOME ALONE
XMAS STORY
WHITE XMAS
IT'S A WONDERFUL LIFE
FIREPLACE
WOOL BLANKETS
"SEASON'S GREETINGS"
"JOY TO THE WORLD"
"MERRY"
"LET IT SNOW"
"BABY ITS COLD OUTSIDE"
"MAKE SPIRITS BRIGHT"
"JINGLE BELLS"
"OH HOLY NIGHT"
"YOU BETTER WATCH OUT..."
etc.

Thumbnails

ow that I have a few distinct concepts figured out from my brainstorming session, I may do thumbnail sketches if I'm deciding between a few typographic lockups (different ways the words can be arranged together in a composition).

My thumbnails are very rough and really just help me work through the lettering hierarchy, making sure I'm emphasizing the most important words when creating the final artwork. Establishing a good hierarchy is especially key if you're working with a longer phrase—the layout can become very busy if you give all the words equal emphasis, or nearly unreadable if you're emphasizing the wrong words.

Lightly sketch out a few small illustrations of possible layouts, emphasizing different key words (like verbs, nouns, and sometimes adjectives and adverbs) and playing down less important words (like articles and prepositions). If you were a sentence-diagramming enthusiast as a kid, like I was, figuring out the more important words in a phrase should be easy. If you weren't, think of it this way: If you were creating a poster for the side of a bus and people were able to glimpse your artwork for only a second or two, what would you want them to read?

Sometimes I'm able to visualize thumbnails or basic layout breakdowns in my head, and sometimes I do extensive thumbnail exploration. Do whatever works best for you and helps you narrow down options for when you get to sketching.

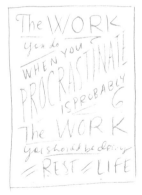

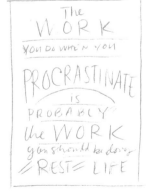

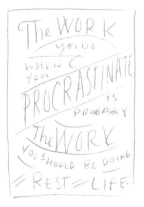

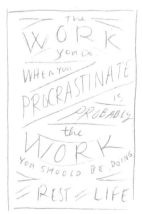

Sketching

Once you've done the research, brainstormed like crazy, and figured out a few basic compositions through thumbnail explorations, you're ready to sit down and make sketches.

Sketches are so important because you can explore different layouts and concepts quickly, getting the client on board before moving ahead with final art. My sketches tend to look quite tight, but that's because instead of doing many iterations on different sheets of paper, I let my sketches evolve slowly, working lightly and loosely at first and then cleaning up and defining the edges of the letterforms until the drawing is complete. I tend to sketch in a few distinct stages:

Step 1: Setting Up Guide Lines

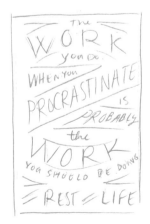

I put a sheet of gridded or lined paper behind my page and, referencing my thumbnails, begin making light pencil guide lines. I draw guides for the baseline, x-height (the height of the lowercase letters), and cap height (the height of the capital letters) of each word or phrase so that every bit of the text is accounted for in the layout, using a ruler for straight baselines and free-handing those that arch or undulate. I leave the gridded paper behind my page only at this stage of sketching, as I find that if the grid is visible the entire time, my letterforms become too boxy and feel un-natural. Some people love working on gridded paper, but I like the little imperfections that show up when you rely more on your eye than math to create something. When I'm done drawing the guides, I can clearly see where each of the words in my composition belongs and can begin sketching the letterforms.

Step 2: Choosing Lettering Styles

crossbar/bar

Deciding on a lettering style or styles can be difficult if you're constantly envisioning the end result instead of making small decisions as you go. While brainstorming, I usually jot down a few styles that feel appropriate for the subject matter (for instance, if I'm drawing a cover for a book showcasing DIY weddings, one of the sketches would definitely showcase a script lettering style), but it's during the sketching that my vision for the letterforms really takes shape. I tend to use a maximum of three lettering styles per sketch, assigning different styles to different kinds of text to create a clear hierarchy. I also make sure, when I'm sending sketches to clients, that there are three distinct sketches with different ideas and layouts explored in each (not three microvariations on one sketch). Clients want to see that you are using your brain and really diving into the material, not just doing the first thing that comes to mind.

Step 3: Lightly Sketching

I build up my letterforms in stages. I begin by using a mechanical pencil, drawing very lightly on the page, mapping out where the letterforms will go, using a hairline to draw "the skeleton," or the basic frame of the letters. As I move onto "the body," adding weight to my skeleton, I draw loosely—sketching the letterform outline or sketching from the inside out (a method that I learned while studying type design at Cooper Union that sometimes feels more like letter sculpture than drawing). Finally, if the design calls for it, I start lightly sketching in "the clothes," or the decorative elements like serifs and swashes (typographical flourishes).

The Skeleton

Usually just a single hairline, the skeleton helps me determine the width of the letters, the x-height, and the general proportions of the components. If I've decided on a script, I explore whether I want it to be upright or slanted (a right-slanted script will likely feel more traditional, an upright script feels more fun and modern, and a back-slanted script specifically evokes styles of the 1930s through the 1950s). If it's a sans serif or serif, I figure out how to best fit the letterforms in their allotted space and make decisions about the crossbar/bar* placement on letterforms to evoke specific feelings or time periods (the low crossbars on Neutraface or similar typefaces evoke a midcentury feel, while very high crossbars can be spotted on certain display faces from the art nouveau period). The typographic lockup and proportions of the page have the biggest effect on the skeleton—if I have to cram a long word onto a single line but still want to give it visual importance, the skeleton must be narrow, the letters taller than they are wide.

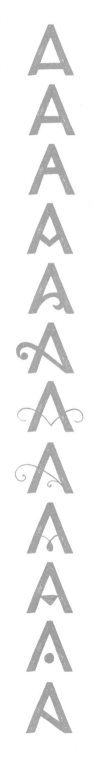

THE WORK YOU DO WHILE YOU PROCRASTINATE IS PROBABLY THE WORK YOU SHOULD BE DOING FOR THE REST OF YOUR LIFE

While it would be impossible for me to teach you everything about letterforms in this book (there are a zillion wonderful incredibly nerdy books already available about the minute details of letterform creation), here are a few things I consider when drawing letters:

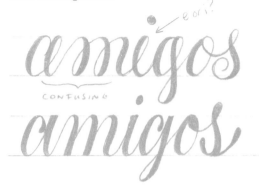

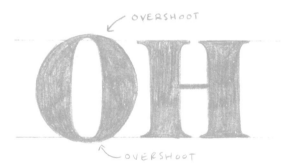

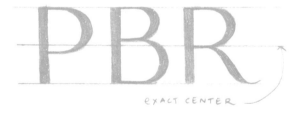

Legibility is always the top concern of my clients (it's brought up at the beginning of every project, so I like to be the first person to mention it—which makes them think I've read their minds, somehow). I try to make sure that the lettering I create is very easy to read without sacrificing style. There are certain letterform shapes that always seem to make clients angsty, especially when drawing scripts. The key is making sure no one letter could be confused for another, and this usually means limiting the amount of loops.

Round letterforms like the *O* dip a little bit below the baseline and extend a little bit above the cap height (or x-height if it's a lowercase letterform). This is called *overshoot*. It ensures that the *O* makes as much contact with the baseline or cap height as the other letterforms, which gives all the letterforms the appearance of having a consistent height.

Symmetry in letterform design doesn't mean perfect mathematical symmetry—you make adjustments to each letterform to create balance between the letter and the white space around it. *B*, *P*, and *R* may all look very similar, but the upper bowls of the letterforms are often different to adjust for letter density and white space.

The negative white space in and around letterforms is as important to the design as the letters themselves. White space affects legibility, and it also informs how parts of the letter should be drawn. I try to create lettering pieces that feel well balanced, with even "color" throughout (when you blur your eyes, there should be no gaping holes between or within letterforms, or parts that feel inky and too dark compared to other letters).

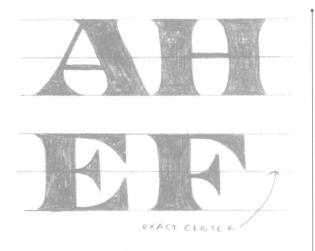

exact center

Crossbars do not need to fall at the same height. If you're shooting for perfectly centered crossbars, it's likely that they'll all end up in different places—the *A* will be lowest (to account for the small amount of white space in the interior apex of the letter), the *E* will be a little higher than the *F* (because the *F* has so much white space below it compared to the *E*) and the *H*'s will be just above the exact center. (If it were in the exact center, it would feel a bit low. It's similar to framing a painting—you always have a little extra mat on the bottom, otherwise it would look as if the painting is sitting too low in the frame. Our eyes play tricks on us and make perfectly centered things feel slightly bottom heavy.)

The Body

This is the "meat" of the letterforms—if you were to compare it to a person or animal, it would be the muscle and fat. You can vary the weight of the body dramatically, and as long as the skeleton remains the same, the letterform will still be recognizable as its base form. If you had a dachshund and it gained a bunch of weight, it would still be recognizable as a dachshund because the skeleton is so distinct. The pen you're using (or pretending to use), the overall desired boldness, and the letter contrast (the difference between the thick and thin strokes) determine what form the body takes.

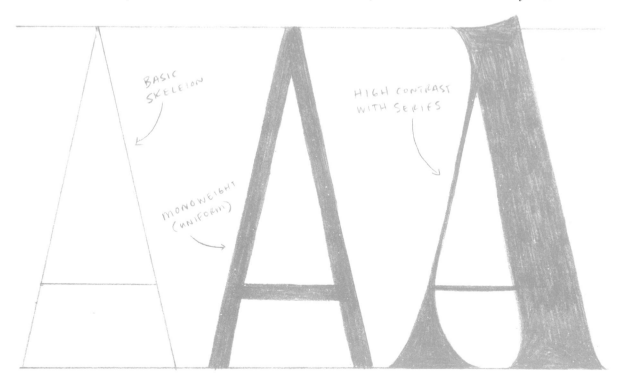

BASIC SKELETON

MONOWEIGHT (UNIFORM)

HIGH CONTRAST WITH SERIFS

Pen Influence

Even though I'm drawing the letters and not writing them with calligraphic pens, I still use the principles of pens and brushes to determine how weight is applied to my letterforms. There's a huge variety of pens and brushes that can influence your work, but here are some I think about (and use often for reference) when working:

Pointed Pen: If you're making something influenced by a pointed pen, the thicks happen where the pen would be pressed down the heaviest. This method is called "expansion" because of how the pen's nib expands on the paper to allow a heavier flow of ink.

The parallel pens I talk about in "The Tools: Analog" section are great for trying out broad-pen styles. You can also pick up a Chisel Tip Sharpie or, as a quick hack, hold two pencils together on a 45-degree angle to draw the letterform.

Broad Pen: If you're drawing letterforms influenced by a broad pen,* the axis of the thicks and thins is tilted so that the thickest points are on the southwest and northeast parts of the letterform, which is known as diagonal stress (this method is called "translation").

Brush Pen or Brushes: If you're working with a brush style, experiment with brush pens to see how a brush affects the weight of the letterforms. There's a beautiful casual quality to brush-influenced lettering that is difficult to achieve without a lot of analog experimentation with actual brushes.

If you use pen logic while you're working, it's easy to figure out where the thicks and thins of letterforms go—thins are always used for upstrokes, and thicks for downstrokes (when using a pointed pen, it becomes immediately clear why this is the case—dragging the pen upward while trying to achieve a thick stroke results in torn paper and lots of ink spatters. Gliding it down and toward you allows the pen nib to separate smoothly and ink to flow freely). Whenever a letter looks a little funky, as yourself, "Am I following pen logic, or did I accidentally invert the contrast?" When you defy pen logic, make sure it looks purposeful and not accidental.

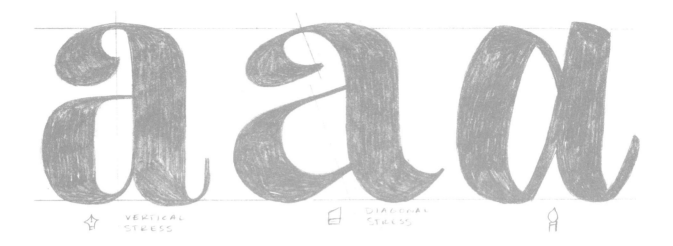

VERTICAL STRESS

DIAGONAL STRESS

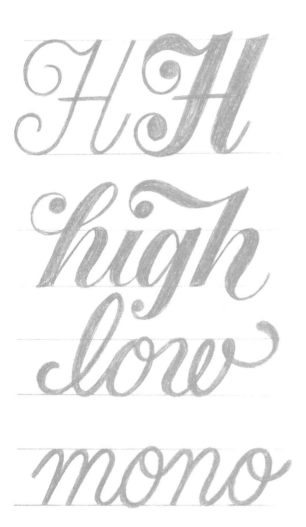

Overall Boldness / Weight

When I'm thinking about how bold or light to make the overall weight of the letterforms, I think about how "loud" I want the piece, or parts of the piece, to be. If certain words need definite emphasis over others, they may be rendered in a bolder weight. If my overall goal is to make something quiet and elegant, the weight of the letterforms will likely be lighter.

High or Low Contrast

Once my pen is decided, I think about the contrast of the letterforms, or the difference between the thicks and thins. A high-contrast lettering style would have thicks that are quite thick and the thins are quite thin. Because of the fashion industry's obsession with Didot and Bodoni, high-contrast typefaces tend to feel very stylish and feminine. In low-contrast styles, the thicks and thins are much closer in weight. In monolinear lettering styles, there's no contrast at all between the thicks and thins (a monolinear script would look as if it were drawn with a piece of string—something with uniform thickness throughout). When you're talking about contrast in typeface design, high-contrast typefaces tend to be used larger (for display or headline type) and low-contrast versions are used smaller (for text or body type), though low- and no-contrast type in the hands of the right designer can be used in a variety of different ways and at vastly varying sizes.

The Clothes

When I first started lettering, I cared more about the clothes than anything else—I used the same basic skeleton over and over again, tacking on serifs and swashes where I saw fit. After a few months, I started to realize that all my work had a sameness to it. Instead of creating distinct lettering styles, I created one style, with many different decorative forms. Imagine if the world's population was completely homogenous—that every person on earth was the same height, the same weight, had the same basic build—and the only thing distinguishing one person from another was clothing and accessories. This is what you create when you focus solely on the clothes and not on the skeleton or body, an army of lettering clones.

Adding Serifs

Serifs can be considered either part of the body or part of the clothes depending on how much impact they have on the overall form of letter. If the serifs are tiny, like on the typeface Copperplate, they disappear when the type is set at very small sizes. If you blur your eyes, and the serifs disappear, I would consider them part of the clothes rather than part of the body. Serifs come in all shapes and sizes, and there are a few things to consider when adding serifs to a letter.

WEIGHT OF SERIFS DOESN'T MATCH THIN.

ABCDEFGH
IJKLMNOPQ
RSTUVWX
YZ
abcdefghijklmno
pqrstuvwxyz

Pen Logic: I know I've mentioned pen logic already, but the pen you've chosen (real or imaginary) also influences what your serifs look like. Say to yourself, "Is the pen I'm using capable of making these serifs?" Look at the thinnest part of your letterform, the part where your pen touches lightest to the paper. Your serifs should never get thinner than that point. You can of course break from logic if you wish, but do so in a way that feels decisive. Mistakes can be beautiful if they're made consistently— always looking as if they were made on purpose and not by accident.

Serif Placement: Many people struggle with where to put serifs. Serifs evolved from entrance and exit strokes of letters in calligraphy, and this knowledge helps you figure out where they're supposed to go on roman letter-forms. On lowercase letters, serifs on the ascenders (*b, d, h, k, l*) occur on the top left side only (the entrance stroke). At the baseline, they may be two-sided (like on the base of an *l*) or occur on the bottom right (the exit stroke). When they happen at the x-height, they can be one-sided entrance strokes or two-sided in some cases. Look at classic (and modern well-designed) typefaces often to see how other type designers deal with serif placement.

PURPOSEFULLY DINKY

Serif Length: This is largely determined by the size at which your lettering or type will be used. Text typefaces have longer serifs than you'd think, because when type is set at small sizes, the serifs should still be visible. You can get away with shorter serifs when your lettering is used bigger, but if they're dinky, make them exude purposeful dinkyness.

Kind of serif: There are a number of kinds of serifs that came about during different historical times. I could get into all sorts of nerdiness talking about serifs, but here are a few varieties you can think about when deciding what works for your lettering:

Bracketed: Bracketed serifs flow from the stem of the letter into the serif and can feel a bit more old-school because of their historical origins. Depending on what kind of pen you're using (or pretending to use) they'll be classified as either old style (influenced by the broad pen we talked about earlier) or transitional (an in-between style that's influenced by both old style and modern styles).

Didone: Bodoni, Didot, and other similar modern typefaces have serifs that are a single monoline (usually perfectly parallel to the baseline) and are the same weight as the thinnest stroke of the letter.

Slab/Egyptian: Slab serifs are rectangular and usually have no bracketing (though Clarendons—(a subcategory of slab serifs) do). Slab serif typefaces tend to be lower in contrast. A famous example is the typeface Rockwell.

Tuscan/Bifurcated: These kinds of serifs can look very circusy but are oh so fun. The serif forks at the center into two distinct parts. If you felt like going really crazy, you could make trifurcated serifs, too!

Adding Swashes

I love swashes, but you should always try to add them sparingly. Look at the word you've drawn and figure out the most logical places for swashes to go, usually on ascenders or descenders of letters, on the left side of a capital letter, or on the last exit stroke of a word. When making decorative lettering, the decorative bits, no matter how over the top they may be, should make sense and feel like natural extensions of the letterforms themselves, not tacked on and unnecessary. Make sure that the swashes feel as if they were drawn with the same writing implement as the letterform itself unless you can draw them drastically different in a way that seems obvious and intentional.

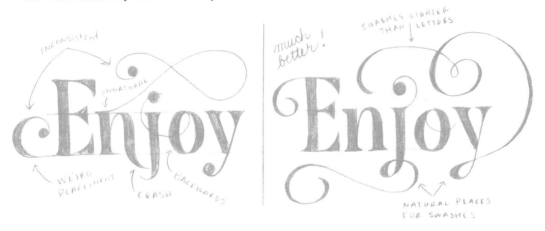

Drop Line, Drop Shade, Drop Shadow

These three variations are borrowed from sign painting but can add a lot of pizzazz to letterforms. If you want to think like a sign painter, always ask yourself, "How can I do this with the least number of 'brush strokes'?" Doing so will help you determine which side the drop shade, shadow, or line should be on (nearly always the left). As letterers, we don't have to worry about "economy of stroke" because we aren't standing on a ladder in the midday sun painting on the side of a building, but the sign painters will love you for making your sign painting–influenced work as accurate as can be to how they would actually do it. If you break the rules, have a reason for it.

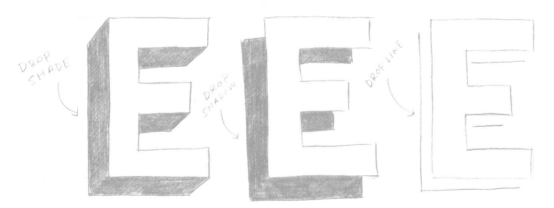

Spurs and Other Fun Stuff

There are about a million ways to decorate a letter. You can tack spurs on one or both sides of your letter-forms; you can add interesting crossbars to your *A*'s, *H*'s, *E*'s, and *F*'s; you can do interior shading and decoration, multiple levels of drop shading—the sky is the limit. Find decorative type and lettering from the Victorian era, research old maps with their ornate engraved city names, look at beautiful sign painting from all over the world (I'm particularly fond of fileteado lettering from Buenos Aires), or explore wood-type collections (particularly in Italy; their wood type is crazy!). Just absorb as much as you can and document the interesting bits—the places where an artist did something unexpected and incredibly imaginative—for use in your work later.

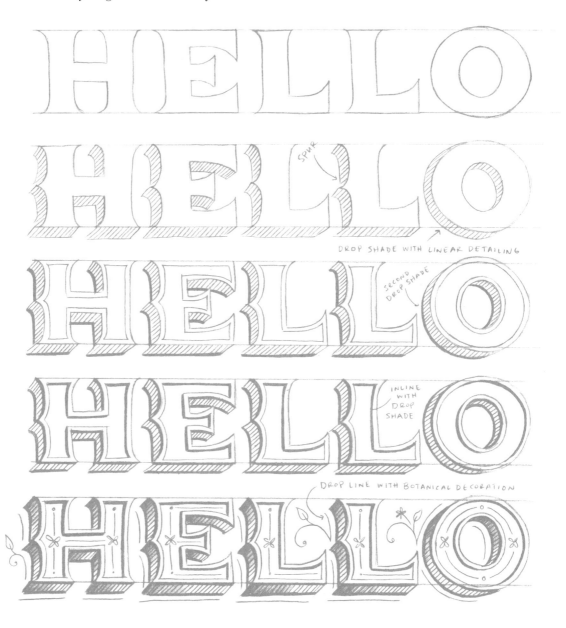

Step 4: Refined Drawing

Once my sketch is laid out loosely, I use my Blackwing pencil to define it more clearly, making edits and changes if necessary and cleaning up swashes and outlines. Sometimes I'll fill in the letterforms if I want to get a better sense of the weight or communicate clearly to the client that the letters will be nice and bold. If there will be actual shading or gradients used in the lettering, I might sketch that in as well. I could've sent the light sketch exactly as is to the client, but both they and I get a better sense of what the final will look like when I take time to draw this darker and more deliberate version of the sketch.

When I send these sketches to the client, I hardly ever colorize them. I want the client to focus on the layout and letterforms, and not be distracted by color. Color is so powerful and so subjective that if I colorized my sketches, the client would, without a doubt, gravitate toward the version in the color palette they like the most, even if they liked the design or letterforms the least. You can use this to your advantage if you really want a client to pick a particular version, colorizing only that sketch (and showing a few color options), which lets them clearly know it's your favorite.

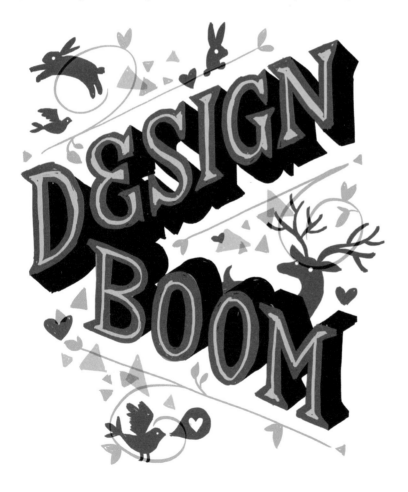

The image on the left is a sketch I drew in Photoshop with a Wacom Cintiq (a display and stylus that lets you directly draw on the screen). For a few months I was obsessed with this magical device and abandoned my sketchbooks. Over time, I found that clients reacted differently to these more finalized looking designs—they scrutinized them more intensely, focusing on small details instead of overall concepts. Presenting initial explorations in pencil (a medium very different from the vector final art) helps clients focus on the big picture.

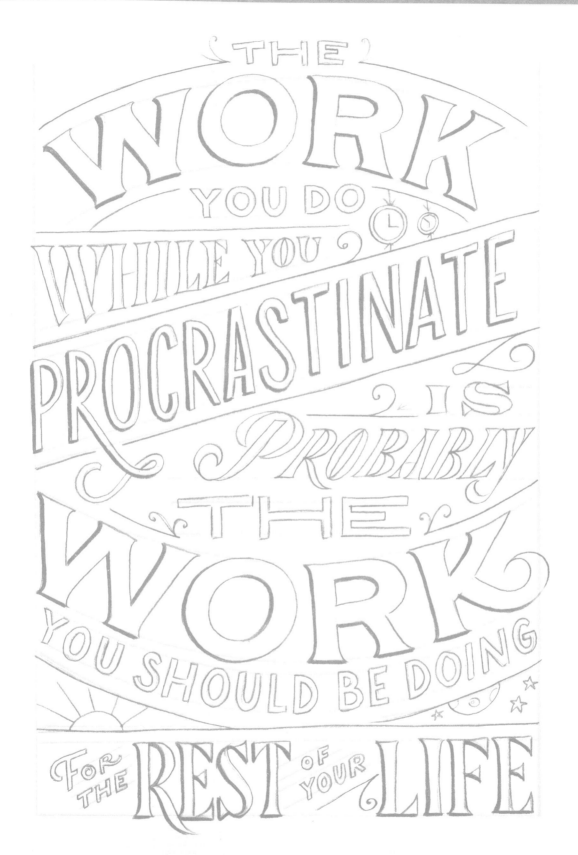

THE WORK YOU DO WHILE YOU PROCRASTINATE IS PROBABLY THE WORK YOU SHOULD BE DOING FOR THE REST OF YOUR LIFE

Vector Drawing

All right, all right, I know that most of you probably bought this book to learn how to draw vector letters, so I won't delay. The first and most important tip I can give you is to learn to love the pen tool: It's the foundation of all vector-based software.

No matter how many crazy effects they bake into Illustrator, the pen tool is the only thing you really need to master and is the single most important tool for vector drawing. It takes time to learn how to use it well and to teach your brain to think of it as just another mark-making device—not dissimilar to a real pen or pencil—and once you have, vector drawing will feel natural. When you're drawing with a pencil on paper, you're not thinking about the point where the pencil touches the paper, you're thinking about the path the pencil is about to take. Even though you're plotting vector points one at a time, the more you do it, the more you start to think of not the point you're currently plotting, but how it will affect the next point and the one after that. Most people never learn how to properly plot anchor points or begin by manipulating basic geometric shapes rather than drawing from scratch, but I'll teach you some best practices that will make your curves smoother and your process more efficient.

Draw, Rinse, Repeat

My vector-drawing process is not dissimilar to the process I use for sketching—I build up the drawing in components, beginning with a skeletal stroke to define the letterforms. If the sketch is very tight or entirely shape-driven (as is often the case with logotypes) I can trace the outline of the sketch directly, but usually I just use the sketch as a guide, especially if I'm drawing a script or if the thins of the letterforms can be defined by a single stroke.

Everything starts with a pencil sketch. Since this was a pro-bono project, I didn't do a large number of pencil sketch explorations. I had a pretty clear idea of what I wanted the logo to look like from the start (a brush script that mimicked nail polish.)

The vector skeleton is created from a single stroke in Adobe Illustrator. I can perfect spacing, swashes, and letterform shapes before further developing the mark.

I spent a lot of time messing around with the skeleton on this one, and realized that some of my original swash choices weren't quite right (the swash running through the *l* would impair legibility, possibly making the *l* look like a *t*). After correcting the skeleton, I redrew the logotype as shape.

Only after the letterforms are perfected do I play with color or additional ornaments (in this case, the highlights added to make it feel more like nail polish). While color is important, it's secondary to the design of the actual letterforms.

Step 1: Setting Up Guides

I drop my sketch onto its own layer in Illustrator, turning the opacity down to 15 percent or so (dark enough that I can still see it clearly but light enough so that it doesn't distract me). I create a layer for guides and start drawing them on that layer as .25-point strokes in a bold color like magenta, defining the baselines, cap heights, and x-heights of letters. I draw strokes as guides (rather than the default Illustrator dragged-from-the-rulers guides) because I often work with all sorts of baselines in the same composition—straight, angled, arched, circular—and it's easier to customize them if they're hand-drawn. I lock both my sketch and guide layers and create a new layer for artwork.

Step 2: The Skeleton

Next I'll draw the skeleton as a single stroke, using my sketch as a guide. The reason why I build from a skeleton up yet again is because by doing so I can make changes and edits to the lettering that weren't easily spotted in the sketch—I'll correct spacing issues between letters, adjust connections, and make sure all my letterforms are on a consistent angle (if italicized) and have a consistent baseline and x-height (or cap height). Once the skeleton is drawn and a minimum stroke width is selected, I usually turn off my sketch, working with just the skeleton and guides from there on out. I will periodically reference my sketch after this point but am not usually tracing it directly. In the example below, you can see how the sketch is used as a basic guide for the vector skeleton, but that I'm correcting letter angles and spacing as I go, so the end result does not perfectly align with the sketch.

There is a logic to how I plot anchor points that I have learned through personal experience and by attending the Type@Cooper program at Cooper Union. Studying under type designers definitely changed the way I approach my work and improved my vector drawing skills tremendously. I find that if I adhere to these rules, I work so much more efficiently and am so much happier with the final result than if I choose to ignore them. When Erik, my studiomate, and I do workshops at our studio, this is what people come for and what they ooh and aah over—super-nerdy vector tips.

The sketch (opacity turned down to 20 percent) with vector guidelines on top. You can see that the sketch doesn't perfectly align, because I am not a robot and my drawings aren't perfect.

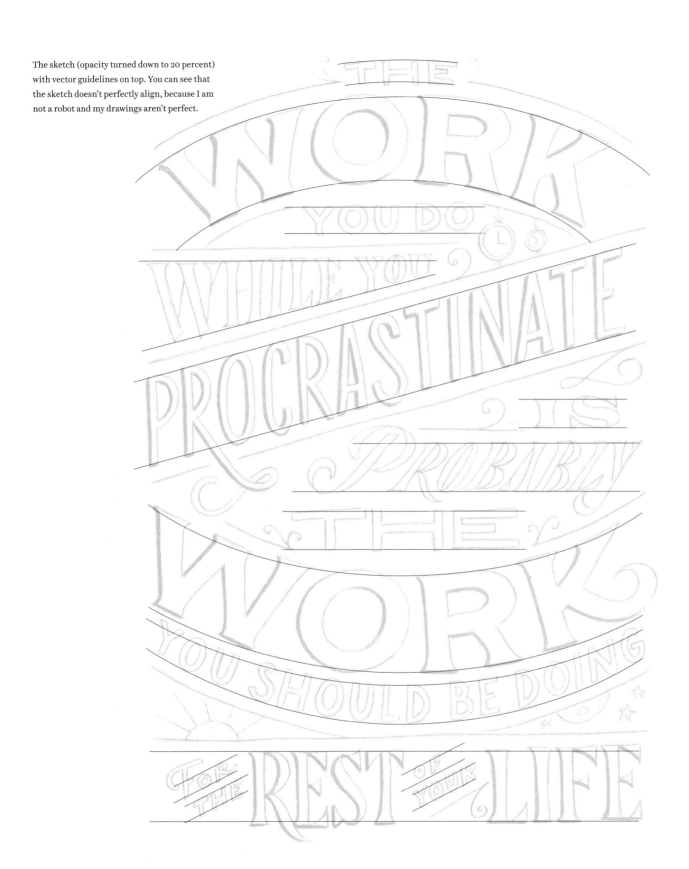

Proper Point Placement

Basic Point Plotting

Anchor points are the building blocks of vector artwork and are used to define the edge of a letterform when drawing in Illustrator or font design software. They define each shift in angle, be it sharp or curved. For boxier forms, it's easy to see where the points should be placed, but for curved forms, it can seem a bit tricky. The goal is to have just enough points to define the shape—problems occur when there are too few or too many anchor points. Below are some tips on point placement and illustrations showing good and bad point placement.

Plotting Points on Curved Forms

Find the Extrema

A perfect circle consists of four anchor points with symmetrical Bézier handles.[1] There are anchor points at the northernmost, southernmost, easternmost, and westernmost parts of the shape. These points are the curve extrema, and type designers (and savvy letterers) plot their anchor points on the extrema of curves whenever possible. Even if you draw a circle with the shape tool in Illustrator, you'll find that the program plots points this way.

Even on italicized letters, the points are plotted on the extrema, not on the "top" and "bottom" of the letter, as you may have guessed. To find the extrema on any letterform with curves, draw a box around the exterior of the letter and another around any interior counters (the negative space inside the letterform) and look at where the edges of the letter shapes touch the boxes—those are the extrema.

I tend to plot just the north and south anchor points first on curves (especially when drawing scripts), adding east and west points as needed after. This allows me to very quickly draw the basic shapes of my letters—they look super-funky until I sit down and start futzing with the handles to perfect my shapes.

Pretty Handles

As you draw anchor points on the extrema of the shape and drag out each anchor point's Bézier handles to create the curve, hold down Shift. This will ensure that the handle is perfectly vertical (they'll be vertical on east and west

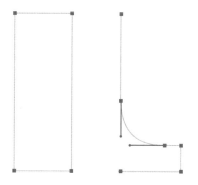

1

Bézier handles: In vector-drawing programs, anchor points on Bézier curves can be further controlled by manipulating their attached handlebars.

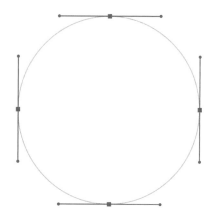

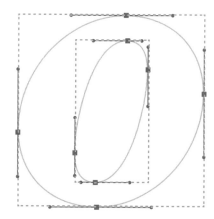

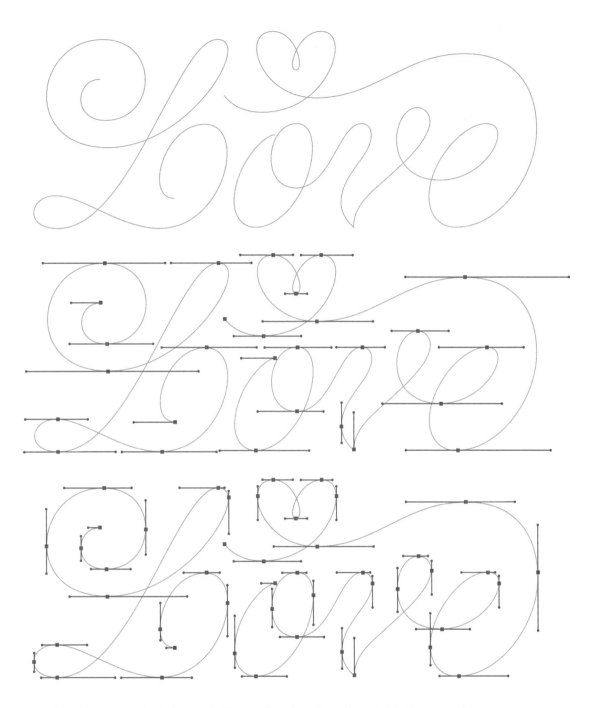

anchor points) or perfectly horizontal (on north and south anchor points). There are a few reasons why type designers plot anchor points and deal with Bézier handles this way, but the reason why you should adopt this method is that doing so makes it a heck of a lot easier to adjust your drawing later. When you make adjustments to a curve, you can adjust it one handle at a time, holding down the Shift key as you move an individual handle closer or farther away from the anchor point it's attached to. By holding down the Shift key, you ensure that only the anchor point and handle you're currently adjusting is affected, which allows for complete precision and much swifter editing.

Rounded Corner Shapes

When working with rounded rectangle shapes (such as those you might find on a bracketed serif), remember that you want an anchor point at the entrance and exit of each curve. Look at how Illustrator plots points on the shape tool's rounded rectangle—there are always two points to every corner, not one, and if you think of each rounded corner as a quadrant of a circle, the points are plotted perfectly on the extrema.

These rounded rectangle shapes are seen often in letterforms—any time a curved part of a letter begins to straighten out, you'll need appropriate anchor points for the curve and a point where the curve begins to flatten to a straight.

When you're working with the angled strokes of certain letterforms, like *A*, *M*, *N*, *V*, *W*, *Y*, or *Z*, you'll sometimes encounter straights merging into curves in a way that does not allow you to plot points on the extrema. In cases like these, just remember that if there is a curve, have an anchor point with Bézier handles at the entrance and exits of the curve. On an *A* with a bracketed serif, the Bézier handles of anchor point #1 follow the angle of the downstroke, while the Bézier handles of anchor point #2 can be perfectly horizontal.

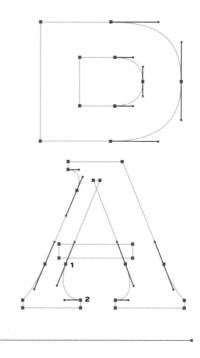

Let the Handles Share the Work

When you're finessing curves, it's important to make sure that each curve is defined by two Bézier handles, and that one handle isn't doing way more work than the other. Usually when I have a bit of stubborn lumpiness in a curve (or some undesirable flatness), it's because one of the handles isn't pulling its weight.

I don't shoot for perfect mathematical symmetry, because I like for my work to look as if it was made by a human and not a robot, but I try to get it as close as possible by eyeing it. On a perfect circle, the handles will be all the same length, but on other shapes you'll see a different kind of logic emerge. On an italicized *O*, for example, you can see that the handles of the inner counter aren't symmetrical but that certain handles relate to one another.

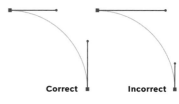

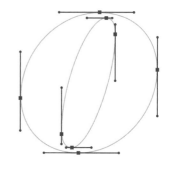

Never Cross the Streams

A very important rule worth following is to never let the Bézier handles of a curve cross each other (or even imply that a future cross will occur). If you need to tighten a curve and find that your handles have become so long that they cross over each other, move your points and shorten your handles so that this doesn't occur. You'll notice right away that if you adhere to this rule, your curves will be far less funky.

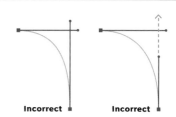

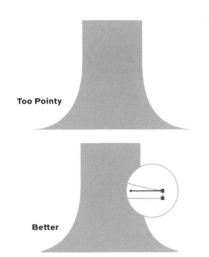

Too Pointy

Better

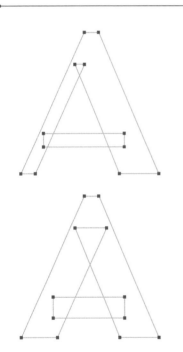

Other Vector Lettering Tips

Square Off Sharp Points

There's a weird optical illusion that can happen when a serif or swash comes to too sharp a point—it looks almost as if there is a thin hairline coming off if it. If you terminate your sharp points with a small flat table top, it eliminates this problem and also makes it a lot easier to add strokes and effects to the letterforms later. This is not saying that all pointed swashes and serifs must terminate this way. Use your best judgment about whether table-topping your points is necessary.

Create Overlaps to Ease Editing

This is best explained through a visual example. If I were drawing a capital *A*, in the inner apex (the highest pointy point), I would have not one anchor point, but two, used in a very different way than the previous table-topping example: One anchor point is plotted at the terminus of each of the angles, forming a small triangle in the way they overlap each other.

Drawing this way is super handy, because you can make adjustments to the weight of one side of the letter without affecting the other. In the case of this *A*, maybe I want to transform it from a low-contrast to a high-contrast letterform. If I just had one point in that inner apex, there would be a lot of adjusting to do after moving the points around, but with it set up as overlapping strokes, it's quick and easy.

Step 3: **The Body**

There are a few ways that I add weight to letterforms. The most precise way is to draw shapes on top of the strokes, making sure that the connections between the shapes and strokes are as smooth as possible. I enjoy working this way because it gives me the most control.

When I'm working on a script, in particular a low-contrast script, I can use the width tool in Illustrator, which lets you add width variance to a stroke. This tool is fantastic but has a few short-comings and can at times be a bit buggy. Sometimes it's best to go about things the long way because the results are more predictable.

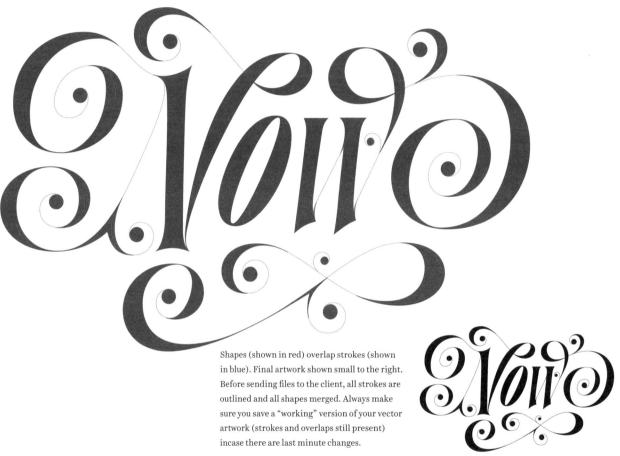

Shapes (shown in red) overlap strokes (shown in blue). Final artwork shown small to the right. Before sending files to the client, all strokes are outlined and all shapes merged. Always make sure you save a "working" version of your vector artwork (strokes and overlaps still present) incase there are last minute changes.

I can reuse sections of my letterforms if it makes sense, but I usually end up making a lot of customizations and adjustments as I go. As a letterer, you're creating custom artwork. Repeating letterforms may seem like a smart idea sometimes and certainly makes your process faster, but I can't tell you how many times clients have told me that my artwork looks "too much like a font" when I repeat letterforms too much. It's infuriating feedback (since fonts are artwork, too!), but I understand that they want the word or phrase to be really special—to feel unique and impossible to achieve through typesetting.

I always begin by making sure the letterforms are under way before adding in any ornamentation. The sketch is turned off at this point, but I may reference it from time to time.

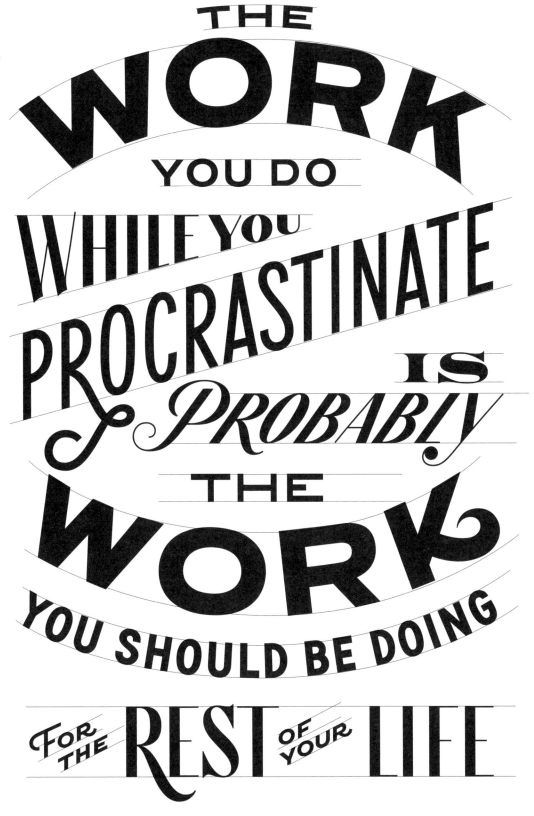

THE WORK YOU DO WHILE YOU PROCRASTINATE IS PROBABLY THE WORK YOU SHOULD BE DOING FOR THE REST OF YOUR LIFE

Step 4: **The Clothes**

I tend to draw serifs, swashes, and the like as separate components (separate shapes on top of the shape of the letterform itself), which allows me to reuse parts or manipulate the serif or swash separately from the letter. As you've probably realized, my process is very additive. I start with something small and simple and build on top of it until the artwork is finalized. It's kind of like building a house: You need to build a solid foundation and frame before you lay down floors or put up walls (and you certainly need all of the above before you add custom light fixtures and doorknobs).

Step 4.5: **Draw It Again (Optional)**

When I work on certain kinds of projects (like logos), a more severe level of perfection is required. My artwork, at this point, is made of a number of components (the skeleton or hairline strokes, the weight shapes I've created, and the serifs, swashes, spurs, etc.), and I try to make the connections of those components as smooth as humanly possible. Though a serif is drawn as a separate shape on top of the stem of a letter, I try to make their point of connection invisible. Sometimes, to be sure that the connections are as perfect as can be, I'll redraw the entire lettering piece, tracing around the contour of what I have created already and treating it almost like a "refined sketch" instead of final artwork.

Another, faster, way to do this is to convert any strokes to shapes and then, using the pathfinder tool, merge all your shapes together. The only issue with using this method is that there will likely be extra anchor points or funky handles that happen when you automate the merge in Illustrator, meaning additional editing will be required that sometimes takes longer than redrawing it from scratch. When true perfection is sought, drawing it again, point by point, is best. Plus, we all need the practice!

When it comes to adding drop shades or shadows to the letters, I first merge all of the separate components (the base letterform shapes and serifs) together using the Unite tool in the Path-finder palette. It's smart to save an unmerged version of your letters as well. You can add a drop shade by either using the Extrude/Bevel effect in Illustrator, or do it manually (which is how I prefer to do it) by duplicating the letters and placing the copy behind the original letters, using anchor points to create the extrusion.

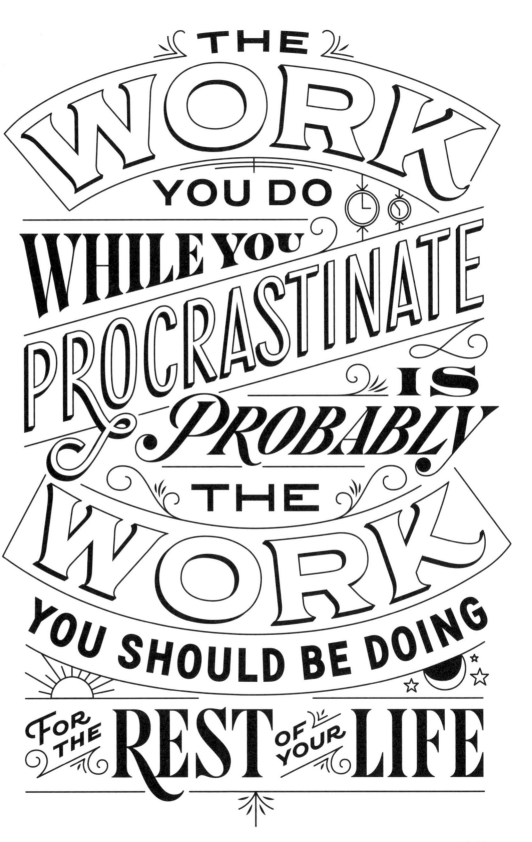

Step 5: Adding Color

When the design of the lettering is finalized and I've added just the right amount of decorative nonsense (be it interior ornamentation, drop shades, borders, calligraphic ornaments, etc.), I consider color. Sometimes I'll work with place-holder colors while developing a lettering piece, but I do most of the color experimentation after the artwork is finalized. When choosing colors, I always make sure there is enough contrast between the lightest and darkest values in the design so that even if it's printed poorly, the lettering is still legible. One of the best ways to see if your design would survive crappy printing is to create a test print with your laser printer. If the design still looks great printed in only black ink and doesn't turn into a grayscale muddy mess, you (and your clients) win.

Normal Color Swatches

Spot Color Swatches
It's very important to note that accidentally using spot colors in a file that is intended to print with CMYK inks (cyan, magenta, yellow, and black—the standard four color printing set up), can be a very pricey mistake. Each spot color creates a new color plate, rather than utilizing CMYK inks. This book utilizes a spot color—metallic silver—on top of the standard CMYK.

Using Global Color Swatches

One tip that I learned while working for Headcase is to set up global color swatches at the beginning of a project. Global color swatches (in Illustrator) behave like spot colors (allowing you to create hues of that color, like you can with Pantone colors) but are still CMYK or RGB process colors. You can tell a global swatch apart from a normal or spot swatch because it has a small white triangle in the corner but no dot within that triangle.

The reason why global color swatches are spectacular is because you can change the color of the swatch itself (by double clicking it and adjusting the CMYK or RGB breakdown) and it will globally change any shape or stroke that uses that swatch. This means no more "select same fill" "select same stroke" blah blah blah. You can make color adjustments incredibly fast and try out color options easily.

When I set up global swatches for an editorial job or any lettering assignment that prints with CMYK inks (and not foil or a limited number of spot colors), I create a white swatch, light gray swatch, medium gray swatch, dark gray swatch, and black swatch. These are placeholder colors that represent the range of values I hope to represent in my color selection later. I love working with limited color palettes when possible and always feel that it brings sophistication to work.

Global Color Swatches
Global swatches behave like spot colors, allowing you to easily create tints or make global color changes, but work with standard CMYK printing.

THE
WORK
YOU DO
WHILE YOU
PROCRASTINATE
IS
PROBABLY
THE
WORK
YOU SHOULD BE DOING
FOR THE REST OF YOUR LIFE

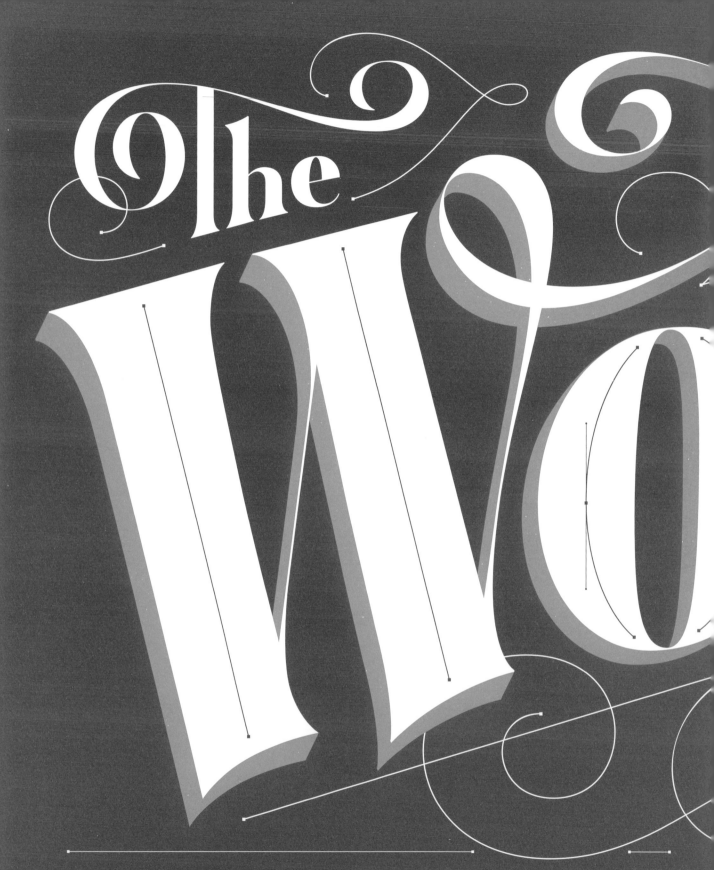

Process in Action: Differing Steps for Different Projects

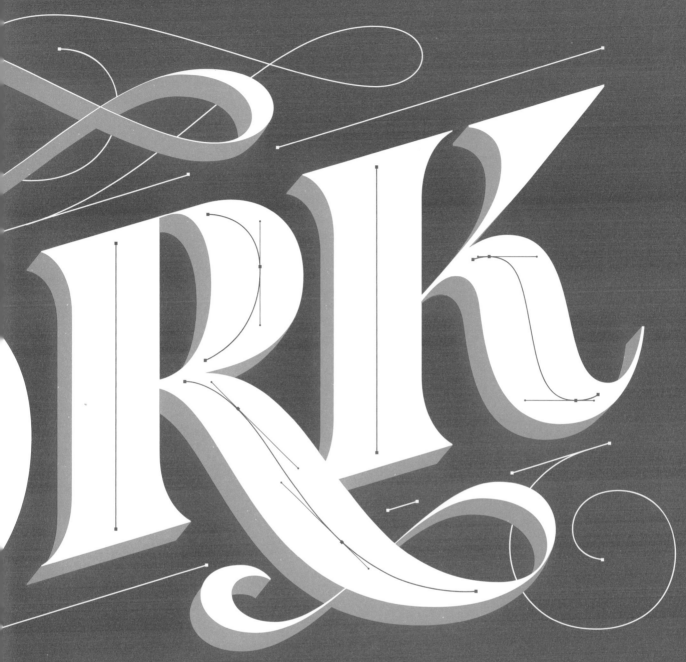

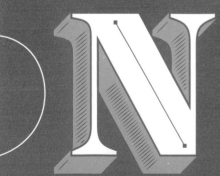

ow that you have an understanding of my process (and probably feel a bit overwhelmed by all the nerd-speak I just bombarded you with), I can show you how it's applied to different kinds of work.

Most of the work that I do falls into these categories: editorial, advertising, books, logos, and miscellaneous (which includes hard-to-categorize printed and non-printed projects, including some of my type design work). Through case studies, you'll see how my process shifts depending on the category of work and who the work is for. We've gotten over the hump of technical talk; on to the pretty pictures!

Editorial

Most letterers and illustrators kick-start their careers with editorial work—it's the bread and butter of the illustration world.

Creating artwork for magazines and newspapers is very fun, and because the timelines are generally pretty tight, you can create a large portfolio of work very quickly. Early in my career, people who stumbled upon my portfolio were shocked at the amount of work I'd created in such a short period of time, and I was able to amass such a big body of work because of all the editorial projects I'd been working on. If I look at my calendar from that time, it's packed with editorial work. I'd be working on up to twelve or fifteen jobs simultaneously, which in retrospect seems crazy. What made it possible to work on so many projects at once was the inflexibility of editorial deadlines—a magazine or newspaper went to press on a certain date, and my artwork had to be delivered by that time. I could piece together my calendar like a complicated puzzle, everything staying neatly in place, jobs hardly ever requiring many rounds of revision or pushing past their original deadlines.

One of the most fun things about editorial work is that you get to read endless fascinating articles and brainstorm about what concepts would best articulate the ideas expressed in them. I particularly love illustrating for science magazines because of all the random things I get to learn about. As an editorial illustrator, you have more freedom to experiment than you often do on other client projects because what you're creating isn't a part of a big expensive campaign. It isn't going to be used by the client on everything they make for all eternity—it exists in just one issue, on one page, as a part of one article of one publication. I don't do as many editorial jobs now as I used to, but I still love to take them on here and there as palate cleansers.

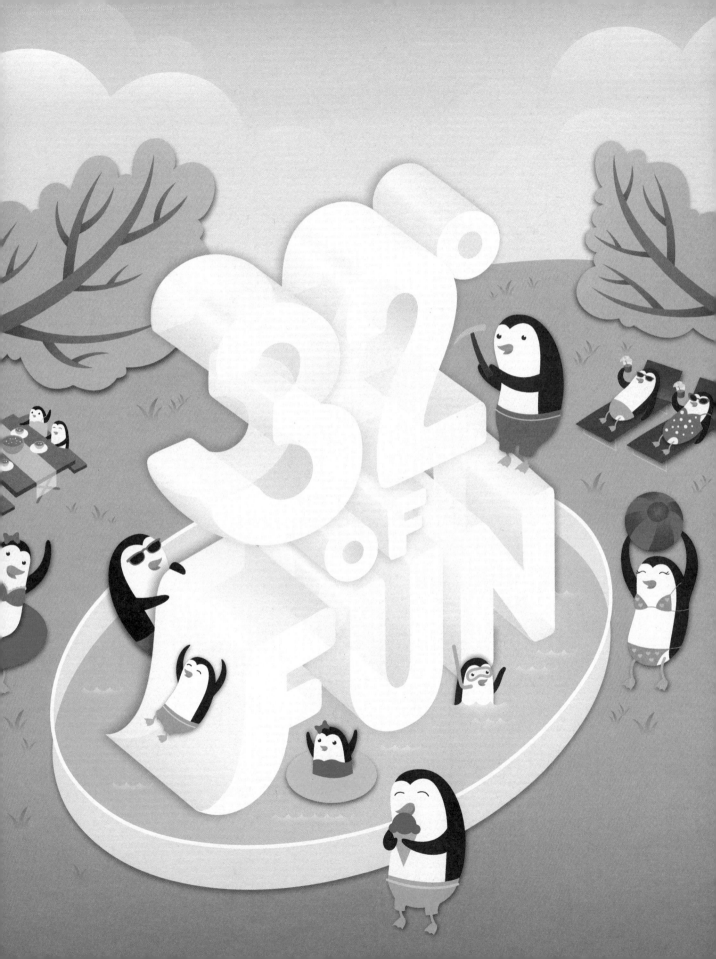

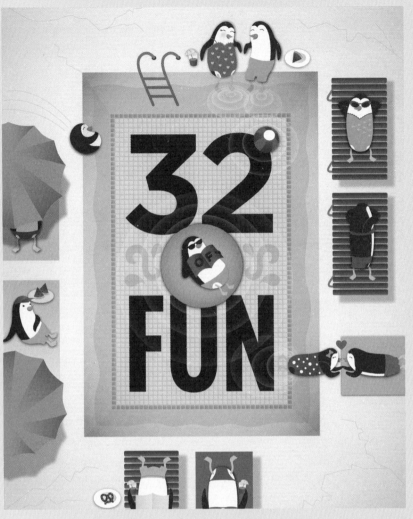

32° of Fun

Client: *Northern Virginia Magazine*
Art Direction: Hana Jung

Much of my early lettering work was quite illustra-tive, like this piece for *Northern Virginia Magazine*. I wasn't quite as crazy about point placement at this time in my career, so everything feels a bit looser. There are a lot of gradients and drop shadows (created not with the drop shadow tool, but by adding a Gaussian blur to duplicated shapes and turning the opacity down to 50 percent or lower), which makes the work feel a bit like cut paper. I used to use a paper texture layer on top of all of my work, which warmed it up and made everything feel cohesive. Now, I try not to rely on textures and tricks to make the work feel "finished."

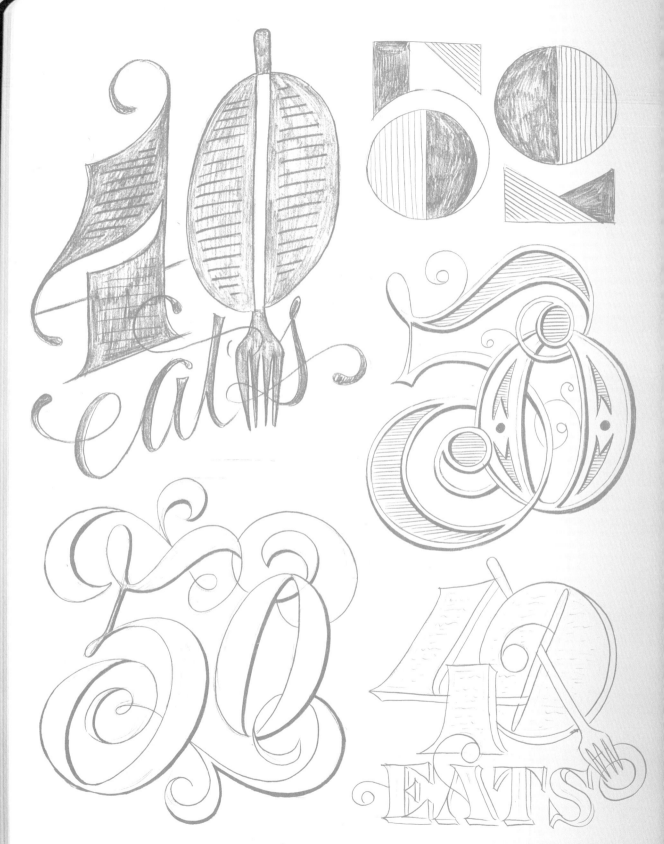

40 Eats

Client: *The Washington Post*
Art Direction: Chris Barber

Chris reached out for me to create the cover of the *Washington Post*'s Weekend section for their annual 40 Eats feature, which highlights forty culinary things to try in DC. In previous issues, a giant *40* was a prominent feature, and as I love giant letters and numbers, I kept that in my design. I wanted to use an unexpected color palette and settled on plum, orange, and cyan.

Fortune 50

Client: *Fortune* magazine
Art Direction: Michael Solita

Fortune contacted me to create a giant *50* for their upcoming issue about the fifty most powerful women. Since the timeline was tight, and the layout wasn't totally nailed down yet, we decided to create two versions—one that was more fancy and feminine and one that was more modern and deco-influenced. The former was the one that ended up in the magazine, but I'm really happy with how both turned out.

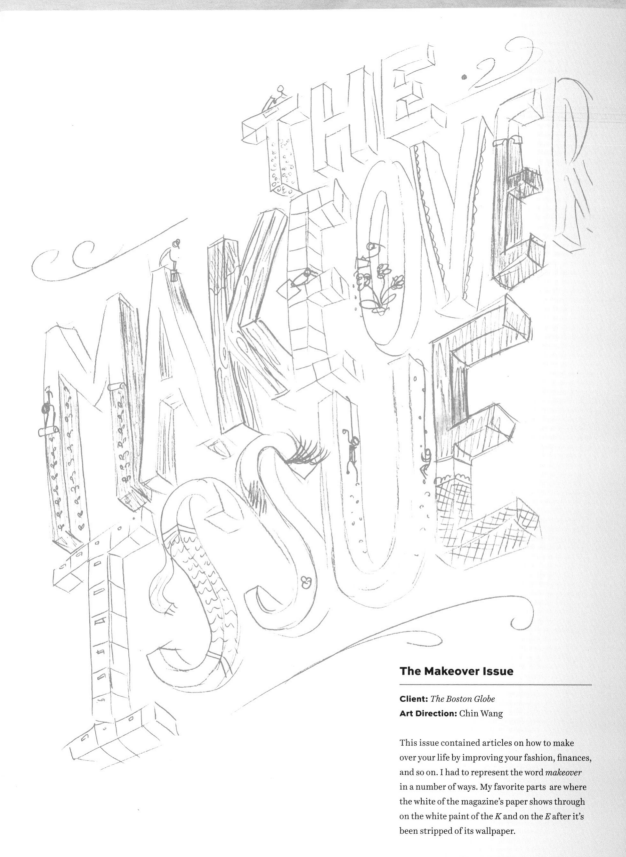

The Makeover Issue

Client: *The Boston Globe*
Art Direction: Chin Wang

This issue contained articles on how to make
over your life by improving your fashion, finances,
and so on. I had to represent the word *makeover*
in a number of ways. My favorite parts are where
the white of the magazine's paper shows through
on the white paint of the *K* and on the *E* after it's
been stripped of its wallpaper.

THE
BOSTON
Globe
05.03.09 MAGAZINE boston.com/magazine

THE MAKEOVER ISSUE

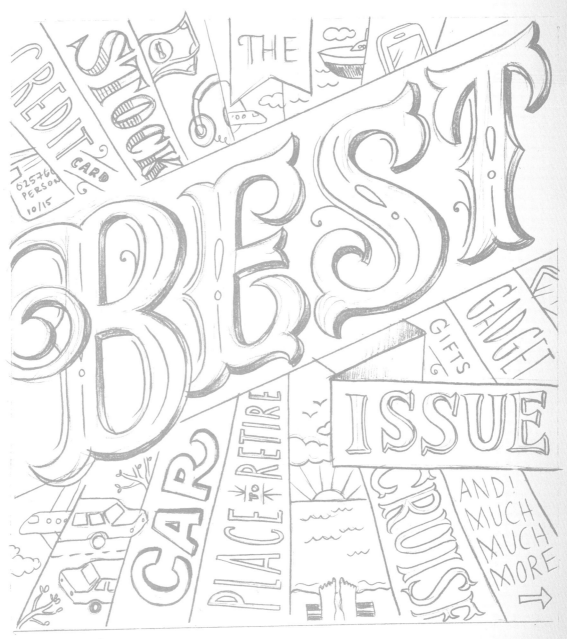

The Best Issue

Client: *Kiplinger's* magazine
Art Direction: Stacie Harrison

One of the biggest challenges as a letterer is dealing with a lot of words in one composition. First, you have to figure out high-priority words (in this case *The Best Issue* had to stand out, especially the word *Best*). Color plays a big part in establishing hierarchy, with the secondary words on blue and the primary words on red.

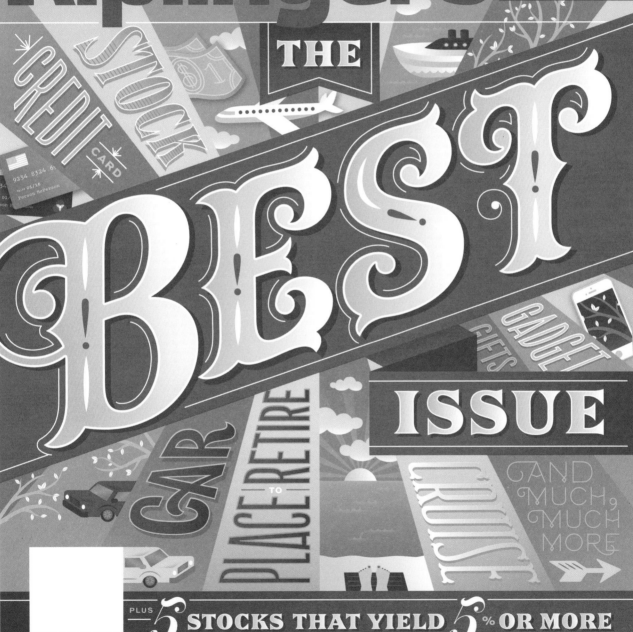

100 BEST VALUES IN PRIVATE COLLEGES

Kiplinger's

THE

BEST

CREDIT CARD

9234 8324 6

Valid 01/16

Person McPerson

STOCK

GADGET GIFTS

ISSUE

CAR

PLACE TO RETIRE

CRUISE

AND MUCH, MUCH MORE

PLUS 5 STOCKS THAT YIELD 5% OR MORE

The *DETAILS* that's what the WORLD is MADE

Wes Anderson

Mohawk Maker Quarterly

Client: Hybrid Design for Mohawk Fine Papers
Art Direction: Kim Yorkers

This lettering was created as a poster insert for *Mohawk Maker Quarterly*. Hybrid hired me to illustrate this Wes Anderson quote because I had worked for him on the *Moonrise Kingdom* titles, so it made for a fun tie-in. We kept the color scheme relatively monochromatic, and the poster was printed with a metallic gold ink, which pops off the dark background. It was really fun to include photo-hunt-esque imagery in the composition that would make fans smile.

SUMMER

Hair Guide

FOR

GROWN-UPS

SUMMER

Hair Guide

FOR

GROWNUPS

WE WON'T REVISIT HOW TO FRENCH-BRAID AND APPLY SUN-IN (*SO '80S*). WHAT WE *WILL* DEAL WITH: ALL THE HAIR ANNOYANCES THAT PLAGUE YOU COME MEMORIAL DAY. NEW FRIZZ FIGHTERS? *CHECK.* PROTECTION FOR AN INCREASINGLY EXPOSED SCALP? *OH YEAH.* PLUS HELP FOR SUN-YELLOWED GRAYS. WE ALSO WEIGH IN ON AN AGE-OLD ARGUMENT: TO GO SUMMER SHORT *OR NOT?* SO POUR YOURSELF A 'TINI AND GET READY FOR A *GREAT-HAIR* SUMMER

by CHRISTINE FELLINGHAM | *photographed by* GEOF KERN

Summer Hair Guide

Client: *More* magazine
Art Direction: Debra Bishop
Photography: Geof Kern

It was absolutely thrilling to work on this piece and also a bit intimidating because Geof Kern's photography for it was so good! As a letterer, you often don't have control of the full composition of a spread or what photography or illustration your artwork is paired with. Working with good art directors is key—people who will not only push you to make great work for them, but also create the most beautiful context possible for that work. Because the photography was so great, we kept the lettering black and white, working with a pretty but modern calligraphic script paired with a serif for the secondary words in the title. I also created a few swashes that were sprinkled throughout the article.

Summer Reading Issue

Client: *The Washington Post*
Art Direction: Carrie Lyle

You're probably starting to notice that there are a lot of "The _____ Issue" pieces being featured. Magazine issues or newspaper sections often have a centralized theme that repeats year after year so dedicated readers can look forward to their favorite features. For this piece, the focus was obviously on good summer reads, so I tried to explore different reading environments (around the campfire, at the beach, and so on) and different "media" the lettering could be created in. The chosen direction reminds me of summers in Pennsylvania, catching fireflies, and having backyard campouts.

Book World

Summer Reading Issue

Book World

SUMMER READING ISSUE

Book World

Summer Reading Issue

Book World

Summer Reading Issue

Book World

Summer Reading Issue

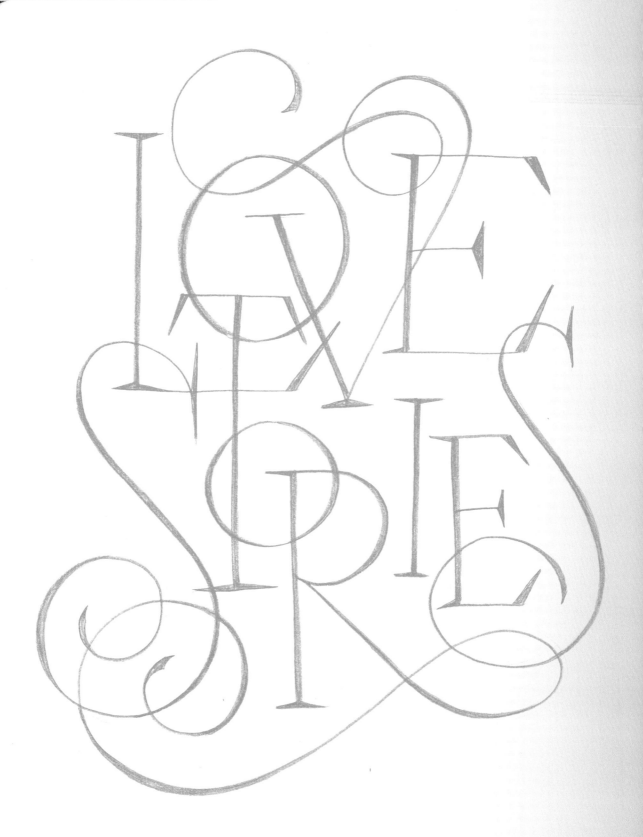

Book Review

The New York Times
FEBRUARY 9, 2014

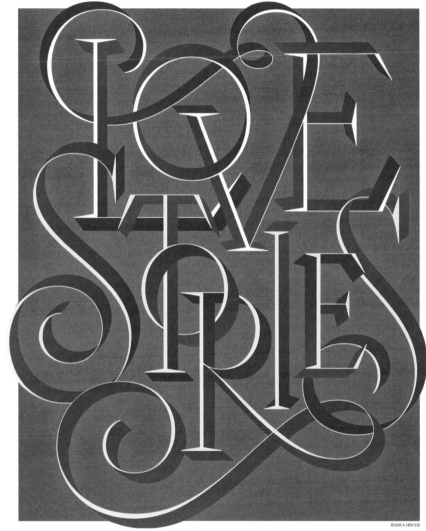

JESSICA HISCHE

Love Stories

Client: *The New York Times*
Art Direction: Nicholas Blechman

Working for the *New York Times* is intimidating. With such an enormous (and generally smart!) readership, you definitely feel pressure to do your best work. I would make jokes early in my career about how I could work on an international ad campaign, with billboards, commercials, the whole nine yards—the kind of work that can pay the bills for months—and still fewer people would see it (and send lovely emails about it) than would see one small editorial piece in *The New York Times*. For this artwork, I had to represent love, but not just romantic love—any kind of love. I tried to convey that any relationship involving love means a complex intertwining of lives.

LOVE STORIES

RIBBON, BUT
LOOSE & FUCKED
UP

INTERLOCKING

NON - ROMANTIC LOVE
- INTERLOCKING / INTERTWINING

AVOID
BOOKS
BOOK COVERS

LOVE
STOR-
YES

THORNY,
MAYBE one
BUD

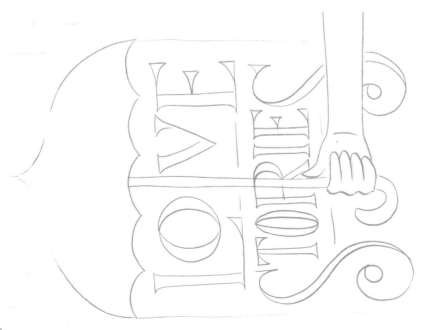

ROMANTIC LOVE

FLOWERS
HEARTS
RIBBONS
VALENTINES
ENGAGEMENT RINGS
ROSES
CARDS
SONNETS
SHAKESPEARE
SCRIPT
CALLIGRAPHY
WEDDING INVITE
EMBRACE
HOLDING UMBRELLA
over significant other

Books

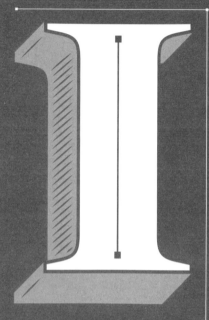

love designing book covers. It's so magical to see something you made printed on a physical object— something people will collect and keep in their homes.

I was never a big reader growing up (I was always the kid drawing in the corner rather than the library-bound bookworm), so it's been an absolute thrill to play a bit of literary catch-up with my book-cover work. I've had the pleasure of designing covers for classic books and new releases—each project with its own unique challenges, be they technical (like foil stamping onto a weird material), conceptual, or artistic.

In the "Research & Brainstorming" section of this book, I talked about absorbing as much as you can about the subject matter before you begin the sketch. For books, that means actually reading the book you're creating a cover for. You can't rely on Wikipedia or SparkNotes for a play-by-play of the plot; you need to dig deeper. Reading summaries might work for narrative illustrative covers, but when you're tasked with representing a story abstractly, through only lettering and decorative elements, you need more than basic facts and plot points. You have to really get to know the characters, visualize the settings, and feel the mood and tone viscerally in order to represent the book well through artwork.

Ideally, I'd read every book cover to cover, but sometimes full manuscripts aren't available (which is often the case when I work with Dave Eggers), or timing doesn't allow you to read a full book by the time sketches are due (when working on the Penguin Drop Caps series, I was tasked with reading *Moby-Dick* and Proust's *Swann's Way* (along with two other titles) in the same six-week period, which my slow-reading self was incapable of doing). I've found that as long as I read at least a third of a book, I can absorb enough of the setting and tone to supplement any plot-summary research. I couldn't live without my Kindle while working on book covers. I love reading physical books, but lugging around several heavy hard-bound books or stacks of printed manuscripts isn't fun, especially when I'm traveling for conferences. I've also found the highlighting feature of Kindles to be very helpful. I highlight individual words and short phrases that create a

Two covers I designed, one for Penguin and the other for St. Martin's Press.

memorable visual for me. If an author describes the wallpaper pattern in a room, I'll highlight it. I'll highlight a passage about a character's hairstyle or the color of her dress. Every mentioned flower and plant, well-described accessory, or china pattern is cataloged for later. Before I begin a brainstorming session, I look through my highlighted notes and transcribe them onto the page, then continue on with my word-association list-making, thumbnails, and sketches.

Freelance graphic designers often create semifinal-looking book covers to present to their publishing clients—they're usually working with existing type-faces and imagery, so comps are the best way to represent their ideas. Since I'm creating all my own assets, it doesn't make sense for me to create semifinal artwork in the early stages of a project. The client must first approve an idea, and the best way for me to represent those ideas is through a sketch. Generally, I present a few sketch options to the art director (usually two or three), showing different ideas, layouts, and lettering styles.

After the sketch is chosen, I create the final vector artwork, taking into consideration the method of printing. For foil-stamped art, I create artwork that's slightly lighter in weight than the desired outcome—the foil expands/bleeds a bit when printed, so if I don't lighten the artwork, it looks thicker than I intended when stamped. For a four-color offset-printed paperback, it's usually more straightforward. Occasionally the art directors I work with will add a special effect to the printing that I discover only when they send me samples—an act that strikes fear in the hearts of most designers but is almost always a fun surprise for me (even when the effects are borderline cheesy).

Barnes & Noble Classics

Client: Sterling Publishing / Barnes & Noble
Art Direction: Jo Obarowski

This series for Barnes & Noble was one of my first big forays into book design (and one of the first times I'd be challenged to create designs suitable for foil stamping). I had no idea when they initially contacted me that I'd end up designing so many books, but every few months a new batch of three or four would come my way. This was such an exciting project, especially since it happened so early in my career. I joked to my studiomates that my former art student self would be having a meltdown at the thought of being able to design covers for classic books, especially when the production would be handled so expertly. Jo, the art director, did a superb job of choosing colors, selecting marbled endpapers and choosing a coordinating edge color for the pages. One of the biggest challenges was making the books feel cohesive, so I chose a typeface for the author's name that would be consistent throughout the series, kept the spine design consistent (while using custom ornamentation for each), and utilized borders on the front and back covers. One of the things that I find the most fascinating about this project is that there isn't a logo or barcode in sight. The books feel perfectly modern but without all the ugly business-related adornments that modern book design usually entails.

SENSE AND Sensibility
JANE AUSTEN

CRIME AND PUNISHMENT
FYODOR DOSTOEVSKY

The Scarlet Letter
NATHANIEL HAWTHORNE

GREAT EXPECTATIONS
CHARLES DICKENS

LITTLE WOMEN
LOUISA MAY ALCOTT

ALICE'S ADVENTURES IN WONDERLAND THROUGH THE LOOKING-GLASS
LEWIS CARROLL

Pride and Prejudice
JANE AUSTEN

JANE EYRE
CHARLOTTE BRONTË

THE ADVENTURES OF TOM SAWYER
MARK TWAIN

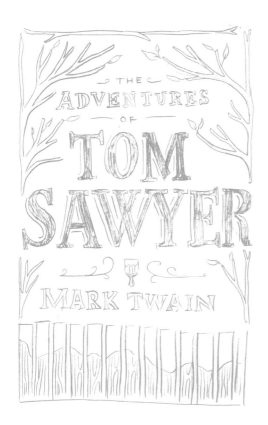

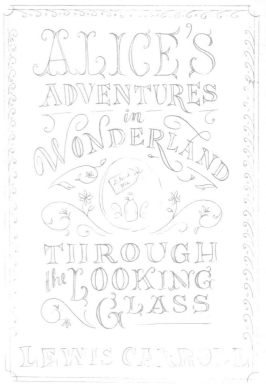

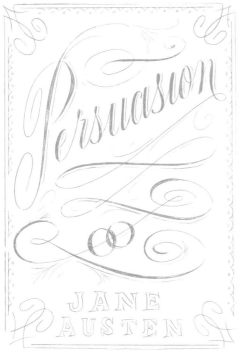

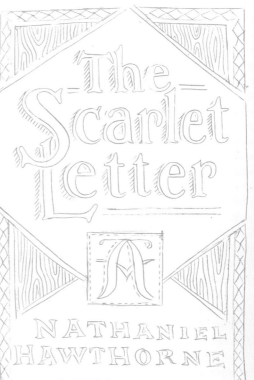

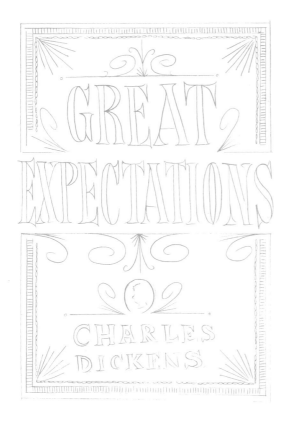

GREAT EXPECTATIONS

CHARLES DICKENS

LITTLE WOMEN

LUISA~MAY ALCOTT

Sense AND Sensibility

JANE AUSTEN

WUTHERING HEIGHTS

EMILY BRONTE

The Circle

Client: McSweeney's/Knopf
Art Direction: Dave Eggers
Printing: Thomson-Shore
Typeface: Neo Tech by Seb Lester

Dave Eggers's book *The Circle* takes place at an idyllic cultish Silicon Valley tech company, so this project was as much an exercise in logo design as it was in book cover design. Dave provided the sketch on the left, saying he wanted to keep the cover very simple, focused on the company's logo, which I would create. The jacket had to be really bold since this book had mass-market appeal, but we made a really intricate case wrap that worked well with the simple jacket. Below is the first sketch I created for the case wrap, which to Dave resembled broken glass and was too ominous, so I focused on a more circular design, alluding to the way social networks radiate out and become interconnected.

When it came to designing the logo, I kept thinking about connectivity and the ways people's lives are woven together online. The chosen direction is a knot surrounding a central *C*. Dave wanted to make sure we didn't give away any of the plot in the logo and to create a logo a company like The Circle might actually use to emphasize its values.

This is one of the other options I had shown, which was deemed too sinister. It definitely has a bit of a HAL from *2001: A Space Odyssey* vibe to it. The design mimicked the knots I remember making at camp—monkey's fists—in which leather strips surround a marble, the leather tightening slowly until the knot completely engulfed the marble.

For the jacket, we printed two-color foil (metallic silver and black) on top of full-bleed offset-printed warm red. Originally we had planned to use a red paper stock, but we couldn't find the right color and our schedule didn't allow for a custom-dyed run of paper. We also wanted to make sure that if the book was successful and needed to be reprinted, that whatever techniques we used in the first round it would be possible to repeat. The case wrap uses an eco leather material, with warm red and silver foil. When I have the opportunity, I always like to make sure that the case wrap is as beautifully designed as the jacket—I know some readers (myself included) tend to remove the jacket from a book if they plan to toss it in a bag. Nothing worse than a crumpled and torn book jacket!

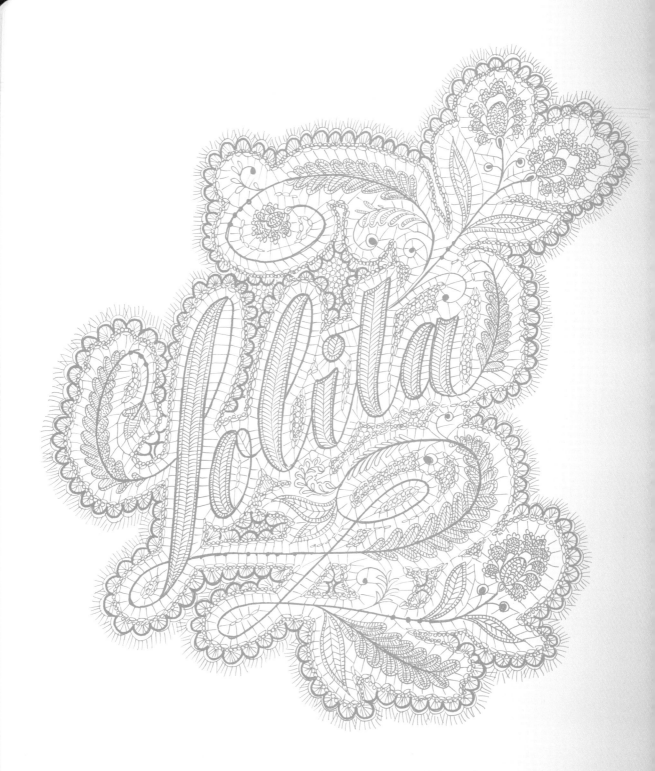

VLADIMIR NABOKOV

The Lolita Book Cover Project

Client: Bertram Architects

It's not often that the sketch I create is actually the final piece, but in the case of the work I did for John Bertram's book *Lolita—The Story of a Cover Girl*, I got to spend a day entirely analog! *Lolita* is an amazing book and so many designers have done beautiful covers for reissues and personal projects. I knew I wanted to do something that played with objects or styles that could be sexy and innocent simultaneously. Lace can symbolize purity or perversity depending on the context, be it for a wedding veil or risqué lingerie. When I was sketching, I thought that ultimately I might want to create the design as vector artwork, but the more complex my drawing became, the more I realized that it would be too difficult to do in the time frame allotted. Also, the imperfection of the sketch made the artwork feel fragile, handmade, and more precious.

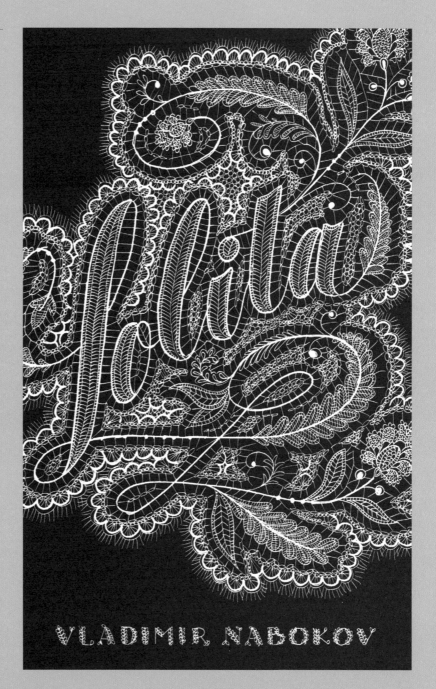

Penguin Drop Caps

Client: Penguin Books
Art Direction: Paul Buckley
Series Editor: Elda Rotor

When Paul Buckley emailed me to say he was going to pitch a series to Penguin's classics editor based on my Daily Drop Cap project, I said, "Sounds great! Thanks!" not expecting much to come of it. About a year later I got an email back saying the series was a go and that, if I was in, I would be illustrating the covers of twenty-six books. This was one of the most challenging projects of my career·for so many reasons—I'd be working on several titles at a time, reading everything cover to cover if I could before brainstorming and

CARLOS RUIS ZAFÒN

SHADOW OF THE WIND

JANE AUSTEN

PRIDE AND PREJUDICE

sketching. Many people thought that we'd just be repurposing drop caps I'd already created for the covers, but each is custom artwork based on the story it illustrates. When you work on covers for books that people adore so completely, you have to really try your best to make something that the biggest fans of the authors (and even the authors themselves) would be proud of. I sketched several conceptual options for each cover in pencil, knowing that the final design would need to translate to two-color foil stamping. Some are illustrative; some are more abstract. Capturing something specific and magic about each of the titles in just one letter was incredibly challenging but ultimately very rewarding. When they released the series, Penguin wasn't shy about giving me credit for the covers, branding the series "Penguin Drop Caps by Jessica Hische," which is the first time a major brand or company released something cobranded with my moniker!

PROJECTION
PROPAGANDA
overlay prisms
vs public
PAST / PRESENT

CELTIC
DESIGN

CHAIN MADE OF
HEXAGONS

GOLD COIN

DRINK FROM
ABOVE

SPEAKEASY WINDOW/
BEDROOM DOOR

BUILDING IN CENTER
DECO ORNAMENTS FILL/
SEEM LIKE CLOUDS

LACE

MOON SILLOED
BEHIND BUILDING

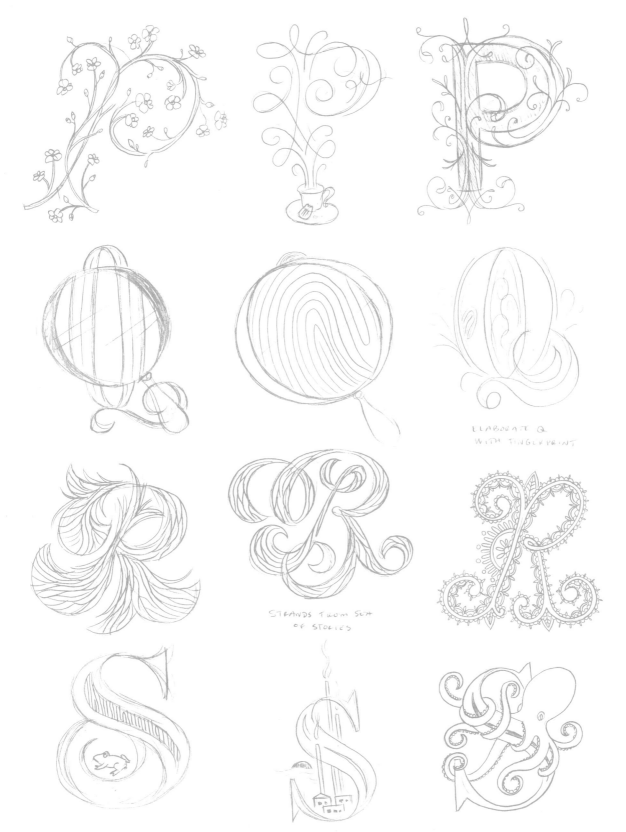

ELABORATE Q
WITH FINGERPRINT

STRANDS FROM SEA
OF STORIES

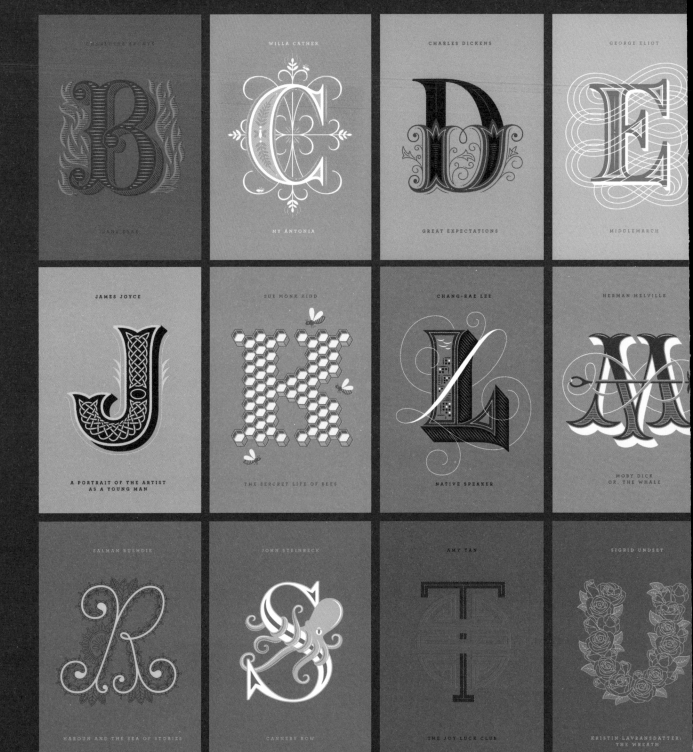

The books, when lined up, create a full rainbow spectrum from *A* to *Z*, which was Paul's wonderful idea. I was worried that we would have some concept color clashing issues on certain titles, but everything worked out superbly! The series took almost two years to complete, and Penguin rolled out the titles in groups, releasing a few at a time. It's crazy to think how many man-hours went into crafting just twenty-six letters.

GUSTAVE FLAUBERT

MADAME BOVARY

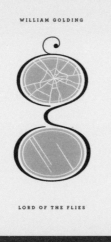

WILLIAM GOLDING

LORD OF THE FLIES

HERMAN HESSE

SIDDHARTHA

KAZUO ISHIGURO

AN ARTIST OF THE FLOATING WORLD

E. NESBIT

FIVE CHILDREN AND IT

JOHN O'HARA

BUTTERFIELD 8

MARCEL PROUST

SWANN'S WAY

ELLERY QUEEN

THE GREEK COFFIN MYSTERY

VOLTAIRE

CANDIDE

WALT WHITMAN

LEAVES OF GRASS
AND SELECTED POEMS AND PROSE

XINRAN

SKY BURIAL

WILLIAM BUTLER YEATS

WHEN YOU ARE OLD

eternal love / friendship
originated in Tibet
but sometimes used
in China

gande-réfue

SHADOWS

109

Advertising

dvertising projects are generally fun and super-collaborative, plus the pay-to-pain ratio is great compared to other kinds of client work (or at least it has been in my experience).

All my work pricing is based on artwork creation + licensing, so when I get to work on a big campaign, the licensing fees can be awesome. I'd dive deeper into pricing here, but I've already done a bit of writing about pricing jobs on my website, and the business of running a design studio is complex enough to warrant its own book.

When working with advertising agencies, I'm hired to do a small part of a larger campaign—my lettering work is used alongside the work of other illustrators and photographers to create the final ad. The art directors I work with do much of the research and brainstorming before hiring me, pitching different directions that the campaign could take, showing samples of my work (and the work of other artists they are thinking about hiring) to the client for approval. I'll be asked to send over a quote, which I discuss with my artist rep (always including a few different usage scenarios), and if everyone can get on the same page, they'll hire me to work on the project.

Aside from the fact that I jump in a little later in the creation process (the client doing most of the research and brainstorming), everything is very similar to how I work with other clients. I do additional brainstorming based on the brief they've sent me, create thumbnails for my own use, sketches to show them, and ultimately vectorized final artwork. Sometimes I'll be hired to create artwork for a pitch and then the campaign goes in another direction, not using my artwork. It's disappointing when this happens, but it's pretty common when working on ad campaigns, so you just have to make sure that your contract specifies that you are paid for any work you are doing for the campaign, whether or not it is used. You won't be paid licensing fees if your artwork is killed (aside from a "presentation only" license, if that's included in your contract), but you should definitely be paid for the work that you've done.

One thing that isn't the best about advertising projects is that I usually have no say about final production of the ads. I don't get to specify paper, print methods, or sometimes even color. The art directors guide the direction the ad takes; I'm just along for a small part of the journey. I make my contribution as good as it can be, and it's up to them to see the full campaign through and turn it into something great and memorable. Not having total control makes some artists anxious, but I find it freeing. Yes, occasionally I am disappointed when a bit of my artwork is changed at the last minute, but usually art directors are very respectful, not messing with what I send them and listening to my opinions about production when I have them.

California Pizza Kitchen

Client: California Pizza Kitchen/Draftfcb
Art Direction: Michael McGrath
Art Buyer: Kathleen Candelaria

These ads for California Pizza Kitchen were challenging, but the parameters were straightforward: Take the provided copy and fit it in the shape of the missing slice of pizza. Projects often begin like this—a client sends a mockup with for-placement-only imagery and the desired copy and then I provide sketches and eventually the finals for how that copy will fit into the ad.

Some prefer milk, some dark, but everyone prefers a little bit more.

Now there's more silky smooth chocolate to love with our new DOVE® Chocolate Bar.

Dove Chocolate

Client: BBDO for Dove Chocolate
Art Direction: Marianna Dutra, Kim Witczak

When an agency calls you and tells you that they're going to take your lettering and make chocolate out of it, it's pretty exciting. In the case of these ads, my deliverables were just black-and-white vector files, which were used to cast metal positives of the lettering. The metal was then coated in chocolate and photographed. Most of the heavy lifting for ad campaigns like this one happens at the start of a project. The lettering style was to remain consistent throughout the ads, so once we nailed it on one, executing the rest went smoothly. I ended up creating a half-baked typeface for this project so that I could typeset the lines quickly, customizing ligatures and swashes once the basic

There's magic in the rich, silky smooth
taste of DOVE® Dark Chocolate.

Add to the magic on Facebook
www.facebook.com/dovechocolate
®/TM trademarks © Mars, Incorporated 2012

There's magic in the rich, silky smooth
taste of DOVE® Dark Chocolate.

Add to the magic on Facebook
www.facebook.com/dovechocolate
®/TM trademarks © Mars, Incorporated 2012

letterforms were in place. For projects like this, where only one type style is used and the scale of the letterforms is consistent throughout, I can use type design to streamline my process—for most other lettering projects it's not possible. I was ecstatic when they came back for more ads (I thought, "Yes! I'm glad I did that extra work up front and made that half-baked typeface! This will be a piece of cake!") but in the end, since over a year had passed, I ended up making a lot of revisions to the original letterforms, so my work on the first round didn't save me all that much time. I have a few barely started typefaces from projects like this, usually consisting of just a few dozen glyphs (the bare essentials that I needed for the project), and most will never be turned into full commercial typefaces.

The real magic is in our rich dark chocolate's ability to disappear

It's not just dark it's Dove.

Just because it's dark doesn't mean it's dark.

A delicious way to overcome your fear of the dark.

Some Prefer milk Some dark but everyone Prefers a little bit More.

The real magic is in our rich dark chocolate's ability to disappear.

It's not just dark. It's Dove.

Just because it's dark doesn't mean it's dark.

A delicious way to overcome your fear of the dark.

Some prefer milk, some dark, but everyone prefers a little bit more.

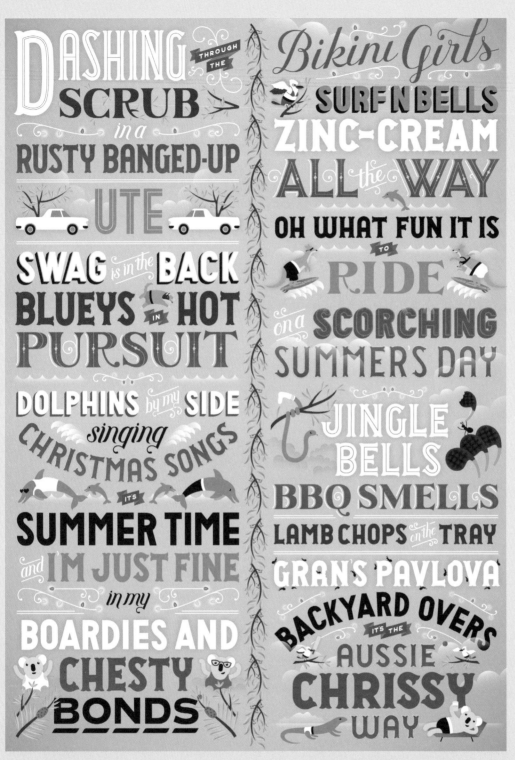

Bonds Holiday

Client: The Campaign Palace/Bonds
Art Direction: Lisa Sherry, Simon Cox

This wrapping paper was designed for a Bonds (the Australian underwear company) mailer. "Jingle Bells" was revamped to suit the Aussie summer heat near Christmas, complete with native fauna in underoos and kangaroos on surfboards. There are several lettering styles used, with color and ornamentation helping unify the layout.

DASHING *THROUGH THE*
SCRUB *in a*
RUSTY BANGED-UP
UTE
SWAG *is in the* BACK
BLUEYS *in* HOT
PURSUIT

DOLPHINS *by my* SIDE
singing
CHRISTMAS SONGS
It's SUMMER-TIME
AND I'M JUST FINE
in my
BOARDIES AND
CHESTY
BONDS

BONDS · BONDS · BONDS · BONDS

BONDS · BONDS · BONDS

Bikini Girls
SURF N BELLS
ZINC~CREAM
ALL *the* WAY
OH WHAT FUN IT IS
to RIDE
on a SCORCHING
SUMMER'S DAY

JINGLE
BELLS
BBQ SMELLS
LAMB CHOPS *on the* TRAY
GRAN'S PAVLOVA
BACKYARD OVERS
it's the
AUSSIE
CHRISSY
WAY

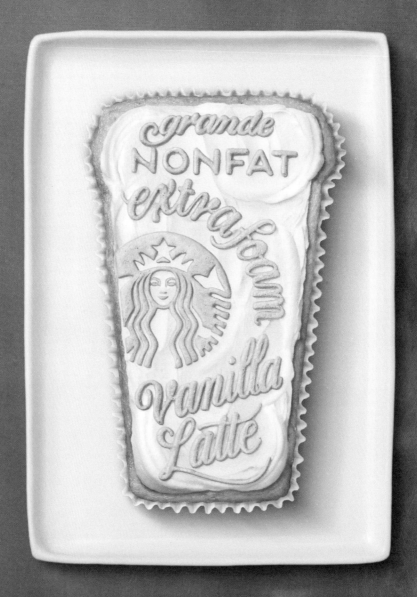

Jessica's "Got My Groove Back" Latte

To each their own latte
Starbucks.com/loveyourlatte

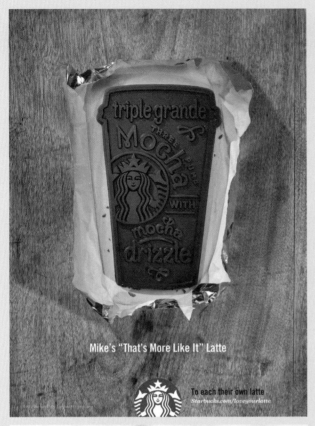

Mike's "That's More Like It" Latte

To each their own latte
Starbucks.com/loveyourlatte

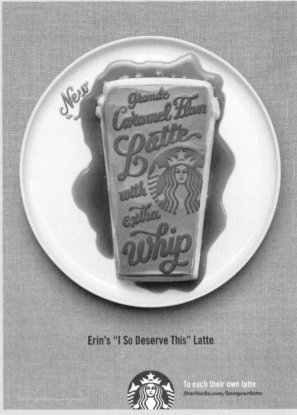

Erin's "I So Deserve This" Latte

To each their own latte
Starbucks.com/loveyourlatte

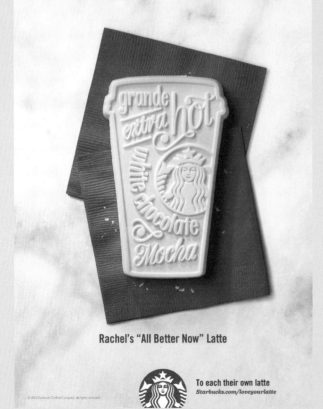

Rachel's "All Better Now" Latte

To each their own latte
Starbucks.com/loveyourlatte

Starbucks

Client: BBDO for Starbucks
Executive Creative Director: Dennis Lim
Associate Creative Director: Rachel Frederick
Junior Art Directors: Alia Roberts, Laura Duncan
Photographer: John Clang

Like the Dove ads I had done for BBDO, my deliverables for these were just black-and-white vector files, with BBDO handling all of the cookie-ifying magic. Also like the Dove ads, they did what they could to turn these into actual photographed desserts, rather than faking it all in a 3-D rendering program. These layouts were deceptively difficult to make work, and getting the legibility just right took time. Starbucks was also very "swash-averse," so we had to find a balance between too-bare-bones and overly decorative lettering. In the end, the ads feel consistent without using consistent lettering styles throughout.

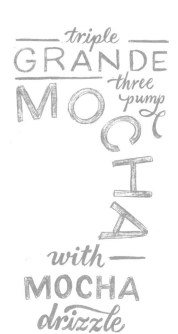

triple GRANDE MOCHA *three pump* with MOCHA *drizzle*

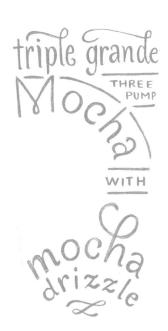

triple grande Mocha THREE PUMP WITH *mocha drizzle*

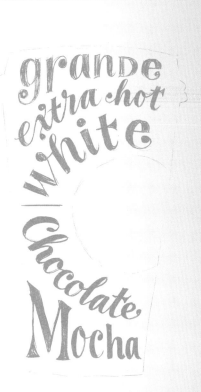

grande extra hot white Chocolate Mocha

GRANDE *nonfat extra foam Vanilla Latte*

INTRODUCING *the New deliciously layered Vanilla Macchiato*

INTRODUCING *the New deliciously layered Vanilla Macchiato*

grande NONFAT *extra foam*

con Crema Creamy *extra milk*

grande extra hot White chocolate Mocha

grande Caramel Flan Latte with extra whip

grande Caramel Flan Latte with extra whip

Introducing the New deliciously layered Vanilla Macchiato

INTRODUCING the New deliciously layered Vanilla Macchiato

Bold espresso BLENDED WITH Sweet Caramel Creamy Milk Crafted BY US. Poured BY You.

Bold espresso blended with Sweet Caramel and Creamy Milk Crafted by us. Poured by you

Bold espresso

Sweet caramel

Unity is
Strength
Knowledge is
Power
Attitude is Everything

Ride for the Roses

Client: The Livestrong Foundation
Art Direction: Meggan Webber

The Livestrong Foundation commissioned me to make a special-edition poster to be given to a select number of donors at one of their biggest fundraising events, Ride for the Roses in Texas. Instead of putting the focus on "Ride for the Roses" itself, I chose to make the poster about the foundation's motto, *Unity is Strength, Knowledge is Power, Attitude is Everything*. The line work around the roses was then foil stamped, so while it looks subtle in these images, the sheen of the foil makes it really stand out in the final.

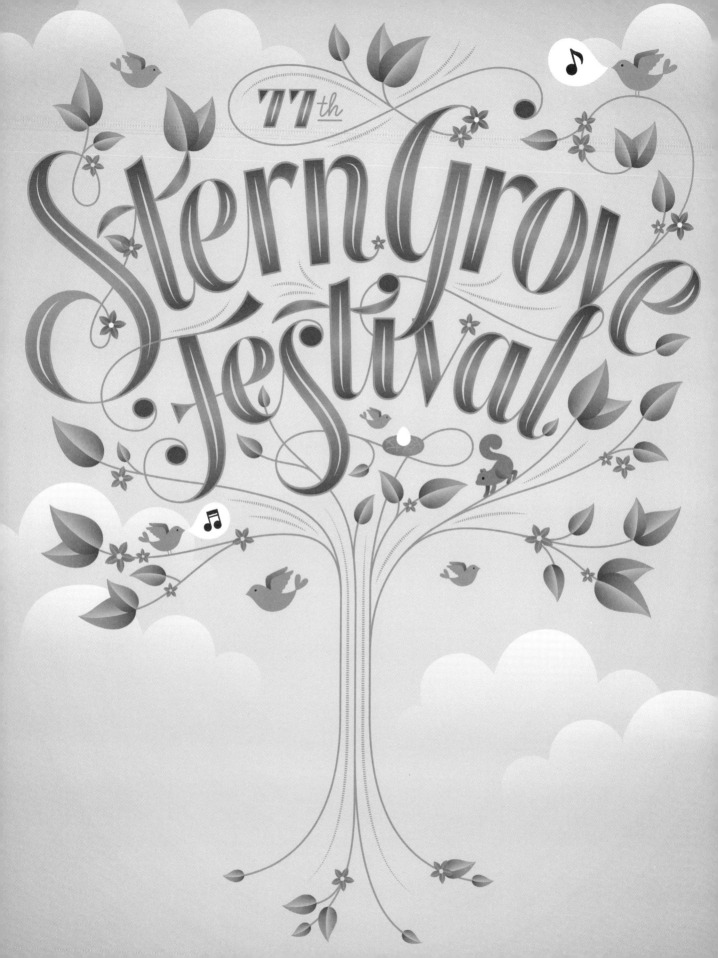

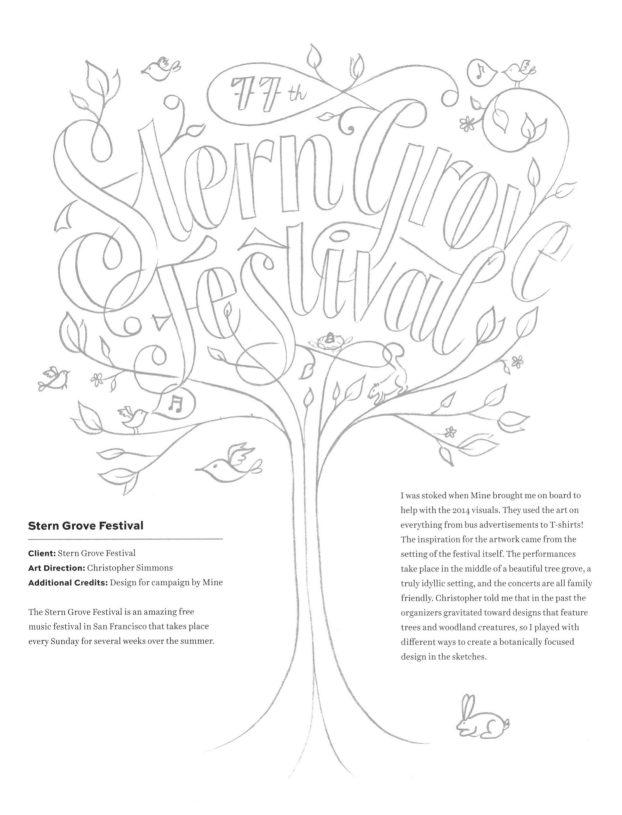

Stern Grove Festival

Client: Stern Grove Festival
Art Direction: Christopher Simmons
Additional Credits: Design for campaign by Mine

The Stern Grove Festival is an amazing free music festival in San Francisco that takes place every Sunday for several weeks over the summer.

I was stoked when Mine brought me on board to help with the 2014 visuals. They used the art on everything from bus advertisements to T-shirts! The inspiration for the artwork came from the setting of the festival itself. The performances take place in the middle of a beautiful tree grove, a truly idyllic setting, and the concerts are all family friendly. Christopher told me that in the past the organizers gravitated toward designs that feature trees and woodland creatures, so I played with different ways to create a botanically focused design in the sketches.

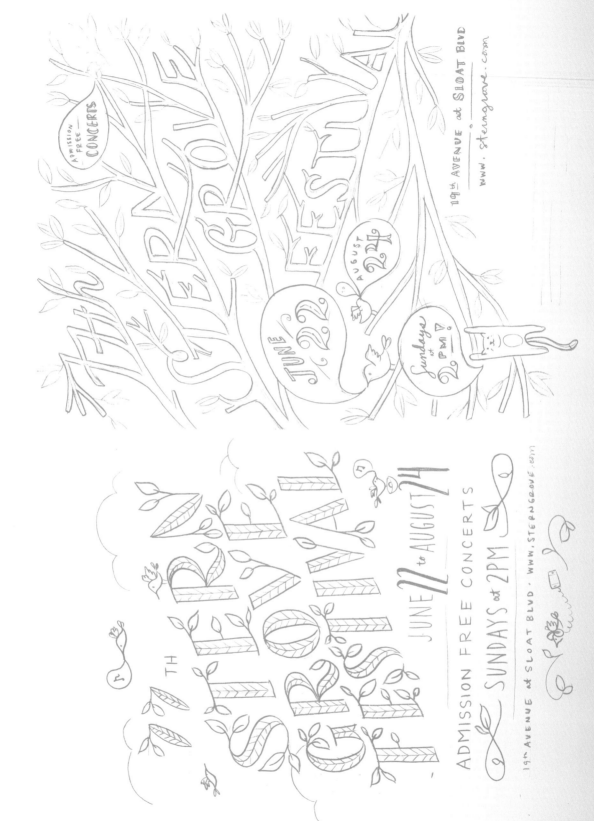

GIFTS THAT MAKE SMART PHONES LOOK STUPID

Fruit Baskets FEED AN OFFICE FOR A DAY

Fruit trees FEED A FAMILY FOR LIFE

NO ONE THINKS A TOILET IS A PERFECT GIFT UNTIL THEY NEED ONE

WHEN YOU GIVE A Fruitcake EVERYONE GOES HUNGRY

THIS SEASON'S MUST HAVE HOLIDAY GIFTS: FOOD AND Water

Oxfam Holiday

Client: BBDO for Oxfam America
Art Direction: Francis Almeda, Liz Miller-Gershfeld

Oxfam is a wonderful organization that encourages people to buy charitable gifts on the behalf of others. BBDO referenced some of my more illustrative work in their brief and wanted the ads to be fun, playful, and attention grabbing. I was even able to collaborate on a motion piece with Laika as a part of the campaign, in which Scarlett Johansson provided the voice for my animated drawings.

This SEASON'S MUST HAVE HOLIDAY GIFTS:

FOOD AND Water

NO ONE THINKS A **TOILET** UNTIL THEY NEED ONE IS A PERFECT GIFT

This campaign was for Oxfam's 2011 holiday season and the ads were displayed on everything from bus shelters to magazines. It was particularly fun to see the ads, printed enormously, in airports scattered throughout the United States! I was living in New York at the time and would spot one almost every day on my way to work or meetings. Seeing your work out in the wild is always exciting.

WHEN YOU Fru GO

ters the
e of
ne

e a
cake
ryone
HUNGRY

GIFTS THAT MAKE
SMART PHONES
LOOK STUPID

Fruit Baskets

FEED AN OFFICE FOR A DAY

Fruit trees

FEED A FAMILY FOR LIFE

Ma, You still look like A MILLION BUCKS. So if you win, can I Borrow Some?

Because my THERAPIST says it's NOT your FAULT

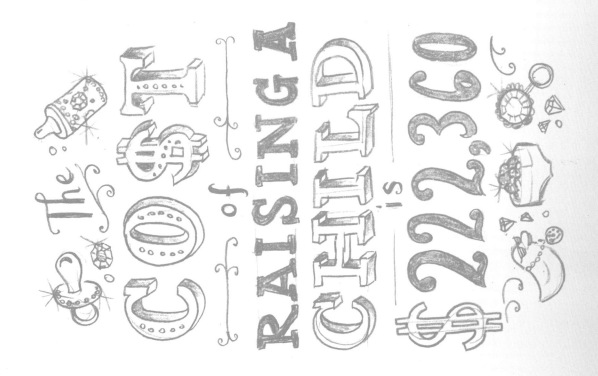

The COST of RAISING A CHILD is $222,360

New York Lottery

Client: DDB/New York Lottery
Art Direction: Menno Kluin, Steve Kashtan, Carol Brandwein, Jane Piampiano

These ads for the New York Lottery were all over New York City in the weeks leading up to Mother's Day. The art direction was straightforward: Using the copy provided create type-driven ads that are fun and readable and incorporate illustrative elements and ornamentation. I kept the color palette fresh and light (these were going up in the spring after all), and while each ad utilizes different colors and type styles, the combination of layout, lettering, line-driven ornamentation, and illustration makes them feel united.

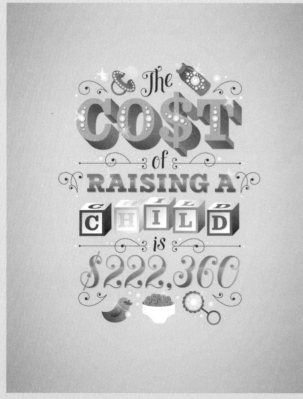

Bertolli Pasta

Client: DDB/Bertolli
Art Direction: Agnes Arceo, Nicole Schultz, Alan Wang, Molly Navalinski
Secondary Typeface: Sweet Sans Pro

I had a blast working with DDB on these ads for Bertolli. We spent the first bit of the project honing the style of the lettering and then worked to keep it consistent throughout the campaign. The result is elegant and eye-catching without being overly decorative. You might be thinking to yourself, "I wonder if she made a custom typeface for this one!" No, I didn't. When it comes to connecting script styles, making a typeface that works perfectly (where all the connections between letters are smooth) takes a ton of time. Also, since the words were being set at different sizes, and since there were a lot of swash characters, it made sense to letter each ad individually.

dress code

— FOR YOUR —

bowties

— FOR YOUR —
PLATE

New

waiting

forever

Tiramisu

Make me happy

minutes from Now

Italy is Served

Italy is Served

133

Logos

L

ogos are one of the most obvious uses for custom lettering out there, and they're also really fun to work on.

Unlike most of the other work I've described so far, logos often involve working directly with the client (rather than working through an agency or publisher), and because of that you need to make sure your contracts are crystal clear, that you're connecting with the client every step of the way, and that you educate the client about your process and the decisions that you're making. Most logo designers never show their pencil sketches to clients and instead work up finalized logos for the first round of presentation. I still prefer to do pencils when possible and share my process with clients, but many have a hard time visualizing what the final will look like when they see a pencil sketch, which is why most designers present finalized designs earlier on in the process.

I prefer to work with other designers and agencies on logo projects, rather than work with the client directly, whenever possible. As a one-woman shop, I don't have the bandwidth to manage giant branding projects, which entail so much more than just logo creation, myself. Identity work involves logo design, creating a voice for the brand through type and color choices, choosing photography and illustration that best represents the brand, lining up designers to establish the web and print presence, creating stationery and brochures, you name it. Some people absolutely love brand-extension work, but I have such a hard time with it—when it comes to client work, I like to speed date. I love having a big mix of a lot of different kinds of projects, rather than working on one project, with one client, for a long period of time. (Please don't think my speed-dating philosophy is reflected in my personal life.)

I take on logo projects sparingly, and my favorite kinds of logos to work on are logo refreshes, where you take an existing brand and massage it into modernity, rather than start from scratch with brand-new explorations. For these, I first do a "physical" of the logo, assessing elements that make it uniquely recognizable that must remain in some way, and pointing out areas for improvement. I criticize style, but mostly show how, with a little tweaking, the mark can be improved dramatically, will work better at small sizes, and so on. Once everyone agrees on my recommended tweaks and in the direction I hope to push the logotype, I get to work.

Party Nails Logo

Client: Taylor Watson/Party Nails

Taylor gave me total freedom on this one, so my sketches were rough to say the least. Party Nails is her side business—she sets up a station in bars on certain nights and does crazy colorful manicures while you drink. I wanted to make her a logo that brought people as much joy as her nail art does, so I went full-out Lisa Frank style on it! The logo is shown in its full rainbow glory, along with two simplified versions. The middle could be used for foil stamping so that the highlights could still be present, and the bottom was the simplest, just the letterforms and no adornment, for when the logo needed to be printed small.

Party Nails

Party Nails

Party Nails

Contact

Most of the logo projects I take on now are revamps—an existing company has a logo they're mostly happy with but know that it could use some refining and modernization. When Designworks in New Zealand contacted me on behalf of their client Contact Energy, they had a little more than a revamp in mind. They were reworking the brand from scratch. They presented me with a very thorough deck and had been using Bello Script as a placeholder for the direction they wanted to take the logo. When working with new clients, especially new clients in different cities and countries, it can take a while for everyone to get on the same page with communication and direction. To me, their brief seemed outstandingly clear—take Bello and make it something more unique for the brand. We had a kickoff phone call and nothing seemed to contradict this assumption.

After I had sent the first round, however, it was clear that what they wanted was something entirely different and, unlike some logo clients I had dealt with in the past, that a formalized presentation deck was necessary. When working with design firms and agencies, I had tended to keep my communication friendly and informal and my files straightforward and not gussied up on letterhead with extensive explanatory writing. This project made it clear just how important a little bit of polish was when it came to client presentations.

For the second round, I started from scratch, utilizing different brush pens to achieve a more casual handwritten look. They were very concerned about the mark looking too much like the Coca-Cola logo, so keeping the script informal made sure that I'd avoid stepping on any existing brands' toes. The client really liked seeing the process, and I helped them narrow down the explorations until one stood out for refinement and vectorization.

This project had a huge impact on how I present work to clients and how I talk about every step I take along the way. Education and transparency is so important in brand work, and being able to defend the work that you're doing clearly (and preemptively) makes a huge difference in whether or not a project is successful.

These first pencil sketches were sent over as simple JPGs and were close to the original Bello Script, used as inspiration for the project. After we cleared up our miscommunication, these were scrapped. The page to the right shows some of the brush pen explorations of the mark, the four on the right being the narrowed-down options for presentation. The client settled on the top option, which I traced in Illustrator with the pen tool and then made many, many changes to regularize the letterforms and make it feel less like a bit of funky lettering and more like a logotype.

Contact Energy

Client: Designworks NZ/Contact Energy
Art Direction: Olivia Swinn, Sam Kershaw, Paul Johnson

Contact

Contact

Contact

Contact

Contact

Contact

Contact

Contact

Contact

Contact

Contact

Contact

Contact

contact

MailChimp

Logo and branding work is incredibly challenging. I was taking it on very infrequently when MailChimp came my way inquiring about a refresh. When clients contact me about logo work, sometimes they are brand-new companies wanting something from scratch—the first bit of design that could help guide the aesthetic sensibilities for the company. I don't consider myself a branding expert in this regard and feel that if you're starting from the ground up, you need someone (really a team of someones) that's in it for the long haul. Good branding design firms don't just hand over a logo, trusting the rest of the brand extension to other designers—they put together guidelines, establish typographic systems, and so on. These kinds of jobs are huge undertakings and usually the work of many designers, not one lone wolf freelancer like myself. What MailChimp needed was different. They had a design team. They had a voice for the brand. The company was successful, and they weren't trying to resurrect their businesses through a design overhaul—they were just self-conscious of a mark that was created quickly at the company's inception. It was fine, but not great. It served its purpose for years but was in need of a little love.

When Ron Lewis contacted me, he trusted in my expertise and knew I'd handle the project sensitively instead of pushing to make drastic changes. When it comes to revamps like this, I tell clients that I want to make it look like the logo had an epic spa weekend and felt renewed and refreshed—not that it underwent $100,000 in plastic surgery and was barely recognizable to its family and friends. I got to work, making small changes one at a time, running them by Ron for approval, often showing him a couple of directions I could take the mark or individual letters. The process was very collaborative. I explained in detail the what and why of every step I took, giving logical reasoning for making certain changes. We slowly massaged the letters until the logotype felt finished. Though the logo underwent many rounds of revision, the process was enjoyable, mostly because it's always fun to work with good people and companies you know and respect.

Many times with logo revamps, I have few pencils to show—the revisions are often so subtle that it's difficult for me to capture them by hand, so I tend to work in vector throughout much of the process. Instead of letting my art boards get out of hand with hundreds of versions of the same mark, I print out the logo when I feel like I've hit a significant step in development and do all of my criticism on paper. With logos, it's especially important to look at laser printouts to catch small imperfections and verify that the direction the mark is going in is correct. By printing it out, you can look at the logo large and small and see where legibility breaks.

MailChimp

Client: MailChimp
Art Direction: Ron Lewis

Old Logo

New Logo

Old Logo

Lightened the overall weight and thinned strokes at meeting points

New Logo

Old Logo

Opened up tight areas for better legibility, especially at small sizes

New Logo

Old Logo

Separated the words and narrowed the C to close up the counter a bit

New Logo

Old Logo

Straightened the baseline a bit without losing the penmanship feel

New Logo

Old Logo

Letterforms become less murky at small sizes

New Logo

When I posted the logo to my website, I knew that the changes I had made were subtle enough that many wouldn't realize that I was showing a brand-new mark, not taking credit for the original. I broke down some of the changes into before and after shots, which gave insight into my thinking. People really responded to seeing the process, and I quickly started getting inquiries from other brands looking for similar subtle logo reboots.

The California Sunday Magazine

I usually don't take on start-from-scratch branding projects, but this was too tempting to pass up. Doug McGray, founder of Pop-Up Magazine, the outrageously popular and excellent series of events, was creating a new magazine. It would be the West Coast equivalent to the *New York Times Magazine*. The content would be meticulously curated and centered around California culture. The mag would utilize local photographers and artists. It was an ambitious project, but it was well on its way to becoming a reality by the time he contacted me to help with the branding work. I insisted that I didn't want to start on the logo until he already had a creative director, or someone who would handle the initial design of the magazine, in place. As a designer, it can be frustrating to inherit someone else's work to incorporate into your own, especially something as important to the direction of a project as the logo. Once Doug hired Carl DeTorres to help with the upfront design work, I was ready to jump in, collaborating with Carl on the direction of the mark.

I had definitely envisioned something stylish—bold with high contrast but still casual and distinctly Californian. We sketched in meetings, discussing that a bold serif italic felt right—not as formal as an upright roman typeface, not as modern as a sans serif. The mark had to have personality, but not so much that it felt overly whimsical or too youthful. The only pencil sketches I had were rough and I'd made them during conversations with Carl and Doug. Most of the work happened once I was in Illustrator, making sure letterforms were consistent but not stiff and that ligatures happened at points where they seemed natural.

After the style for the logo was established, and after Leo Jung (who I knew from my days in New York) was hired as full-time creative director, we set to work on creating custom section headlines and a monogram that could be used in several ways in the magazine. The monogram exploration seemed to take more time than the logo itself, but that's often the case. Parts of a project that seem simple and straightforward are often the hardest to nail down.

Miniseries
Shorts
Stories
Features

California Sunday

Client: *The California Sunday Magazine*
Art Direction: Douglas McGray, Carl De Torres, Leo Jung

The California Sunday Magazine

TCSm

tCSm

CS CS CS

Reminisce

I had worked with Marti Golon before, but as an editorial illustrator for *Reader's Digest*, not a logotype designer. When she contacted me to help redesign the masthead for their publication *Reminisce*, I was up for the challenge. *Reminisce*'s tagline is "The magazine that brings back the good times," and its content is a soup of nostalgia and Americana from the 1900s on. The initial explorations Marti showed me definitely had a 1950s or 1960s kitschy flair, though she wanted to make sure the mark felt a bit more timeless and from a less immediately identifiable era.

She sent over a PDF full of handwritten logos from different department stores, which was a wonderful jumping-off point for exploration. They were all obviously hand done, so I wanted to make sure that the script we ended up with had a lot of calligraphic flair. I played with pens for an afternoon to figure out some basic letterform shapes that might work, but ultimately I ended up working in pencil for the first round of presentation. Marti was pleased with the explorations, so much so that we decided to move forward with vectorizing two options—an upright brush script and a casual calligraphic pointed-pen script. After trying both in the layout, the upright brush script won out, though I would have been happy with either. Shown below is the vectorized alternate option.

Here is the original logo for the magazine (left) and an early exploration by Marti. One of the first major concerns in the redesign was to eliminate the large swashes from the logotype, which often interfered with content below.

Reminisce

Reminisce Magazine

Client: *Reminisce/Reader's Digest*
Art Direction: Marti Golon

Reminisce

Reminisce

Reminisce

Reminisce

RetailMeNot

Trent Walton, one of my "internet friends," approached me about helping his client RetailMeNot with some logo revisions. Trent's studio, Paravel, had been helping RetailMeNot revise the user experience and site design, but both Paravel and the client's designers knew that in the process it was smart to think about updating the logo. RMN is a coupon site—folks search for brands they love and see if there are any active discount codes or coupons available. I had used the site before and had a good experience but was definitely happy to hear that it was getting a facelift, especially by designers whose work I liked. I love being able to collaborate with friends on projects, and I jumped at the opportunity.

The CEO of RetailMeNot was hesitant about making too many changes to the mark, so I started the process by doing a "logo physical"—a detailed criticism of the existing mark showing areas for improvement and giving clear feedback on the revisions I'd make to certain letterforms. Whenever criticizing someone's logo, you have to be very sensitive with language. In this case, the CEO loved the logo and it was his designers who felt strongly about the revision, so I took care not to be too harsh with my remarks. The logo physical proved to the CEO that I was suited for the revise, and we moved forward with my suggested directions.

At first, I just took the existing mark and redrew it, simplifying it and taking into account the changes I outlined in the logo physical. For the second round, I took the mark in a few different directions, some more wildly different than others. In the end, the client settled on a version that was lower contrast than the original and had a much more regular baseline, but still kept the angled *R* that the CEO loved so dearly. We refined the swashes and made them a bit less "groovy," and I created a version of the logo for use at small sizes that had wider letter spacing for better legibility (see below).

Below are some of logos we explored in the second round. The top was closest to the original, the second a slightly toned-down version. The third (a lighter version of the final chosen logo) lowered the contrast and made the swashes a bit less calligraphic. The last was a wild card approach. Trent and his team had loved all of the lettering featured on Chromeography.com and wanted to see what would happen if the brand was revamped to fit in with that aesthetic.

RetailMeNot

Client: Paravel/Retail Me Not
Art Direction: Trent Walton, Reagan Ray, Andy Helms

This is the original logo. First and foremost, I
knew we had to strip away all of the outlines and
drop shades so we could focus on the letterforms
themselves. I couldn't help but think that the
original logo felt very "sporty" and wanted to make
sure that our revised version felt gender-neutral
and appropriate for the industry.

In my logo physical I outlined some of the areas
in need of improvement. First I showed how
inconsistent the thicks and thins were. No existing
tool would create such inconsistent thicks and
thins. The logo was obviously a brush script, but
the brush was behaving weirdly to create such wild
inconsistencies.

Next I simply showed areas where the vector
drawing could use refinement. My goal, always, with
vector work is to hide the fact that it's vector. I don't
ever want anyone to look at my work and say "that's
really good for vector"—they should appreciate the
art in its own right. Vector artwork becomes obvious
when curves aren't smooth and when transitions
between straights and curves are jumpy.

The swash terminals of the lettering were really
inconsistent, so I wanted to make sure that we
addressed them in the revise. Some were lumpy,
some were too thin and wimpy, some felt a little
unresolved. Every mark in a logo should feel
purposeful and natural.

Lastly, some of the letterform angles were off.
Generally, any letter that hits the x-height will be
of a consistent angle, and anything that extends
beyond it (ascenders) will be back-angled very
slightly. If the angles were all perfectly consistent,
long ascenders appear optically to be on a steeper
forward angle than letters along the x-height. The
letters in the logo followed this logic, but a little
too obviously, so I wanted to tone that down.

Miscellaneous

hat follows is a broad category of work, including projects as diverse as wedding invitations, film title design, and artwork for an Oscar party invite.

These projects don't quite fit into any of the previous big categories. Most are paid client jobs hired through individuals or agencies, and some are for fun and self-initiated (like Daily Drop Cap) or pro bono artwork that I created for friends or charities.

The creation process for the work in this section follows the steps I defined in the Process portion of this book: research and brainstorming, thumbnails, sketches, final vector art. What's so amazing about figuring out a step-by-step process to work by is that it makes any project that comes your way seem achievable, whether it's a poster, an invitation, album art, a wine label, a temporary tattoo, or a swim cap! When you can break down the way you approach work into doable steps, anything seems possible. The few projects that defy or build on that process, like any project that involves a bit of typeface design, are called out and explained further.

Florence and the Machine

Client: MSN/Florence and the Machine
Art Direction: Adam Jay Weissman

Whenever I show pencil sketches to clients, I make sure they're as tight as can be, but sometimes I sketch more loosely when I know I'm the only one that is going to see it. For this poster, I was given total freedom to do whatever I wanted, so I didn't have to worry about getting approval on my design before jumping to final. I knew that I wanted to do a script with swashes that flowed together and thought that if I just started drawing the basic letterforms, I could add swashes gradually—the sketch was really just a way for me to figure out the basic word configuration. I ended up utilizing the stroke width tool (which I mentioned in the "Process" section) to create the thicks and thins, and because the contrast was low (the thicks are close in weight to the thins), it turned out great. I did use shape in certain parts, like where the loops filled in on certain letterforms. This poster was created in a very limited edition, so we were able to have some fun with inks. The whole thing was screen printed—the clouds along the edges in metallic gold and the lettering was hit with an extra-special glow-in-the-dark ink so that when you were literally left in the dark, it cast a bit of light into the room.

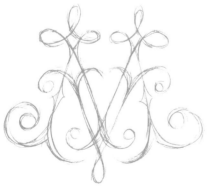
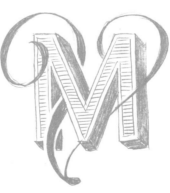
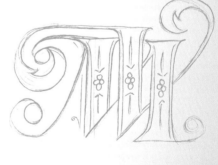

Mahonia Wine Labels

Client: Mahonia Vineyard
Art Direction: Travis Henry

Mahonia Vineyard, a reputable Oregon winery, wanted to create a really special label for a limited-release wine. I wanted to make sure that fans of the vineyard would still recognize the maker, so we kept the general layout similar to other releases and instead focused on making a really unique piece of artwork for the letter-pressed and foil-stamped label (see previous page). I created a custom monogram, thinking that any future releases would have their own unique *MV* monogram on the label and a special color palette chosen for each wine. These three are the first in what will hopefully be a big and artistically challenging series.

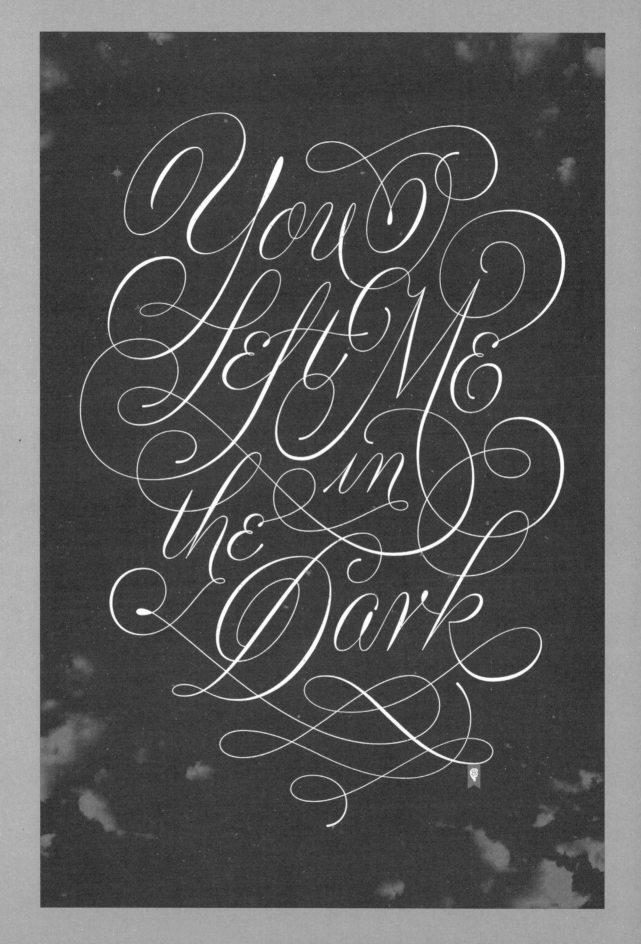

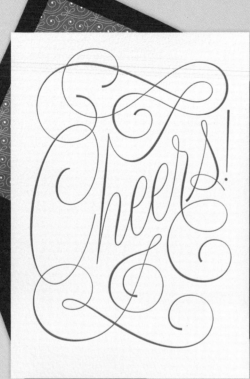

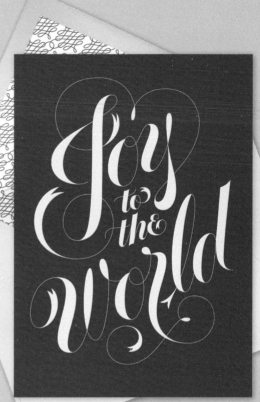

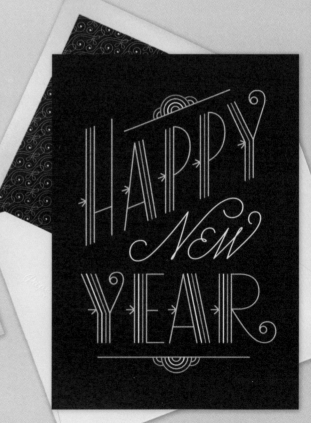

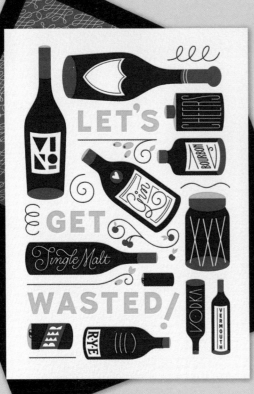

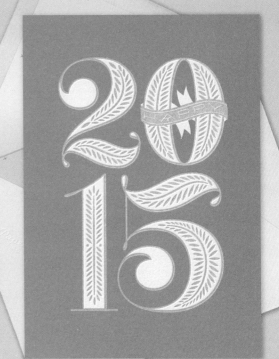

Paperless Post Cards

Client: Paperless Post
Art Direction: Shauna Leytus

I was introduced to Paperless Post by a friend
in New York who used the service to create her
bachelorette party invitations. This was in 2009,
and Paperless Post was a very young company
with limited designs available, but still, I thought
they were doing something really unique. When
they approached me about a partnership in 2013,
I was immediately on board, knowing how much
they cared about design and making the e-card
experience more special and memorable. These
are a few designs I created for their 2014–2015
holiday season, but the partnership is ongoing.
Every season, they send me a very loose brief of
what they're looking for, and I have a lot of room
to explore designs, write my own copy, and so on.
I turn over vector artwork and they transform it
into letterpressed and foil-stamped-looking final
art. Many of the designs I've created for them
are also available as physical cards, through
their Paper by Paperless Post line.

Cheers

Joy to the World

10 9 8 7 6 5 4 3 2 1...

Happy New Year

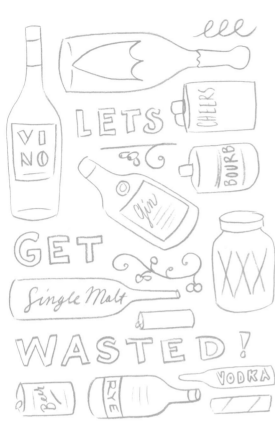

VINO
LETS
CHEERS
BOURB
Gin
GET
Single Malt
XXX
WASTED!
Beer
RYE
VODKA

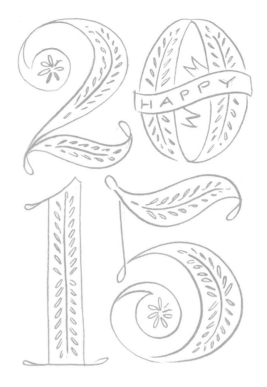

2015
HAPPY

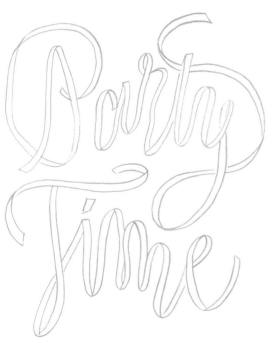

Party Time

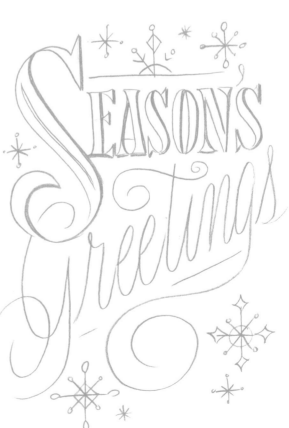

SEASONS
Greetings

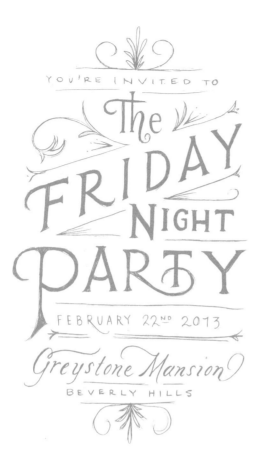

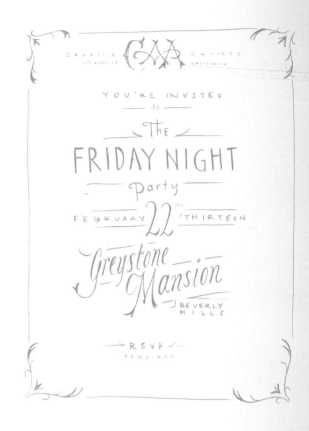

CAA Invitations

Client: Creative Artists Agency
Art Direction: Thao Nguyen

CAA is one of the premier Hollywood talent agencies, and when Thao hired me to help them design the invite to their Friday-night Oscar party, I jumped at the chance. In 2012 the party's decorations were modeled after *The Great Gatsby*, as the Baz Luhrmann adaptation had been released that year. I explored different options, some less obviously deco than others, but ultimately we went with something that was instantly recognizable as being from that era. The invitation existed only online, so I created a website for it as well. It was simple—just the card on a patterned background that flipped when you moused over it and clicked through to the RSVP address—but it was a big hit. I was able to attend the party, which was one of the most surreal nights of my life. I thought it would be a big affair, but it was actually quite intimate.

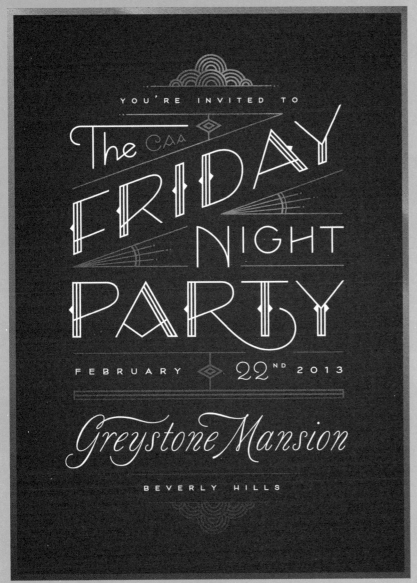

Jones or Jennifer Lawrence, Reese Witherspoon, and Ellen. Thao had also told me that the previous designer was hired by Spike Jonze to do some work on a film, so I felt like I had to be on my best behavior (despite the four fingers of scotch they were pouring me at each trip to the bar.)

They ended up hiring me again the following year, this time with the theme of "Old Hollywood." I researched hand-drawn titles from old movies, and we ended up settling on two styles of lettering—a vintage script with a low x-height and a stylized sans serif. Because the sans was going to be used quite a bit, I ended up creating a makeshift typeface for the project that was later expanded into a full commercial typeface I named Silencio Sans (after silent films). The website was a bit different for this design as well. I didn't want to just repeat myself by using the card-flipping trick from the year before, so instead I had parts of the invitation fade in and out like movie titles, using jQuery animations to make it work. The site had a fun strange responsiveness to it as well—because the background clouds were absolutely placed in the northeast, northwest, southeast, and southwest corners of the containing box, when the window was resized the clouds moved and overlapped in different ways. I was able to go to the party again in 2013, and it was just as awkward, but at least I was prepared for it.

Russ and I went together, and we had high hopes of talking up celebrities, especially since I had done work for Wes Anderson that year so could engage in actual industry-related conversation. When we walked in we quickly noticed that the ratio of A-list celebrities to "normal people" was outrageously high. Even the waitstaff reminded me of a more attractive cast of *Party Down*, underworked actors trying to make it in Hollywood, unconcerned with the small talk that Russ and I tried to make with them. We didn't try to strike up conversations with any celebrities because it was painfully clear that this was their night to relax and be with friends before the big work weekend of Oscar madness. My family definitely gave me grief about not talking to anyone, but it was impossible. I would have had to interrupt conversations between George Clooney and Tommy Lee

THE CAA
Friday Night
PARTY

ABCDEFGHIJKLMNOPQRSTUVWXYZ

ABCDEFGHIJKLMNOPQRSTUVWXYZ

Friday
FEBRUARY 28TH 2014

Private Residence
BEVERLY HILLS

Click to
RSVP

OSCARPARTY @ CAA.COM
ARRIVAL & PARKING DETAILS WILL BE GIVEN UPON CONFIRMED RSVP

INVITATION STRICTLY NON-TRANSFERABLE

THE CAA

Friday Night

PARTY

THE CAA

Friday Night Party

THE
CAA

FRIDAY
NIGHT

Party

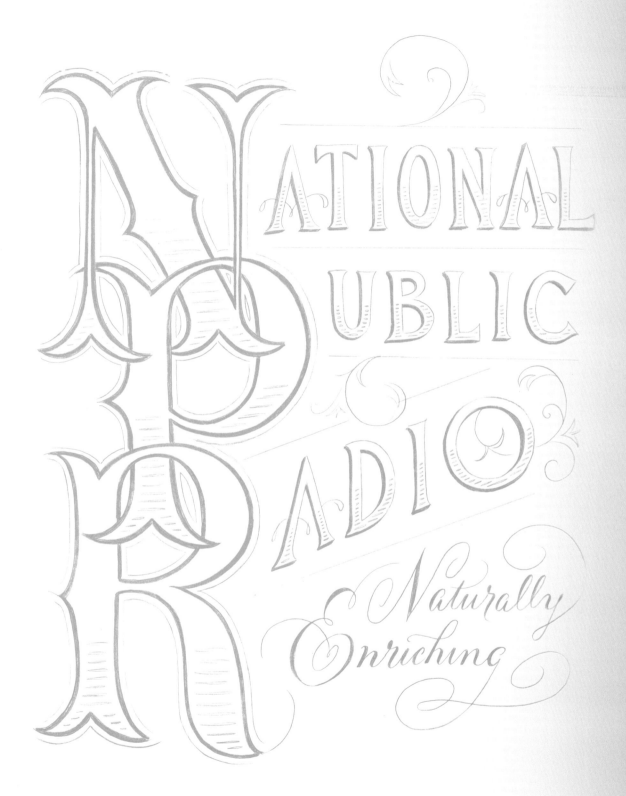

NPR Calendar

Client: National Public Radio
Art Direction: Katie Burk

I consume a massive amount of "guilty pleasure" media, but NPR is one of very few sources of brain-nourishing goodness that regularly makes its way to my ears. I wanted to really capture that typographically, and while working on my design I kept coming back to vintage food packaging (and not just of the kitschy 1950s and '60s variety) and early Americana. NPR is the enriching good-for-you stuff that not only helps you feel better for all the other sugary nonsense you indulge in but also makes you want to be better in the future. Each month of the calendar features a different excellent artist's work, and I was ecstatic when they ended up using my artwork on the cover. I kept the color palette as simple as possible so the lettering could really shine.

Each day is
A GRAND
ADVENTURE
A
GRADUATE
an
OPPORTUNITY
EXPLORE LEARN
& DREAM

EACH DAY
is
at
GRAND
ADVENTURE
an
OPPORTUNITY
to
EXPLORE
LEARN & DREAM

So Long TA~TA
BYE GOODBYE LATER
B
Y Farewell!
E HASTA LUEGO CIAO
toodle-loo

ON YOUR
CONFIRMATION

AND BE

Papyrus Cards

Client: Papyrus
Art Direction: varies per project: Rebecca Shank, Jennifer Lew, Kari Sullivan, Cielomar Cuevas, Ed Hakari, Katri Haycock

Papyrus creates absolutely beautiful high-end greeting cards, and I'm happy I've had the opportunity to work with them on more than a dozen different designs. They really go all out with production. What you see here are my flat vector finals, but Papyrus always utilizes interesting and complicated printing techniques. The good-bye card to the right was produced with letterpress, the Halloween card below with two-color foil stamping, and the Noel card with dimensional letterforms, foil, and rhinestones. My artwork creation timelines are pretty average (two weeks or so from start to finish), but the cards take quite a while to hit the shelves—up to a year and a half. They're definitely exciting to work on, though it's painful waiting so long to show them to the world!

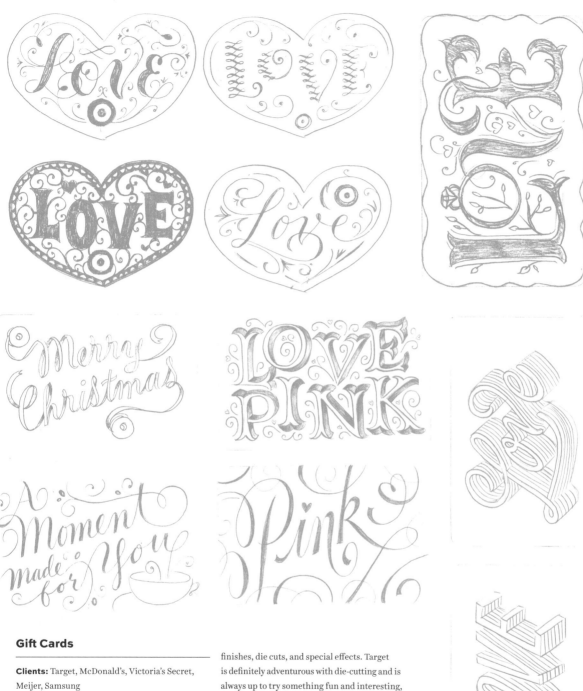

Gift Cards

Clients: Target, McDonald's, Victoria's Secret, Meijer, Samsung

One of my first major international clients was Samsung Korea—I was hired to create more than a dozen holiday gift cards for them. That project may have been what caught the eye of Target, whom I've had the pleasure of working with many times over the years. Gift cards are really fun to work on, and I love when I can get creative with finishes, die cuts, and special effects. Target is definitely adventurous with die-cutting and is always up to try something fun and interesting, like the silhouetted cupcake card shown on the left or the undulating-edged Love card (the one with an engagement ring in it), which was printed on a matte stock and included foil stamping and embossing. The challenge with all gift card design is to make something that stands out in a sea of other cards—a card that people would happily give in lieu of a physical gift.

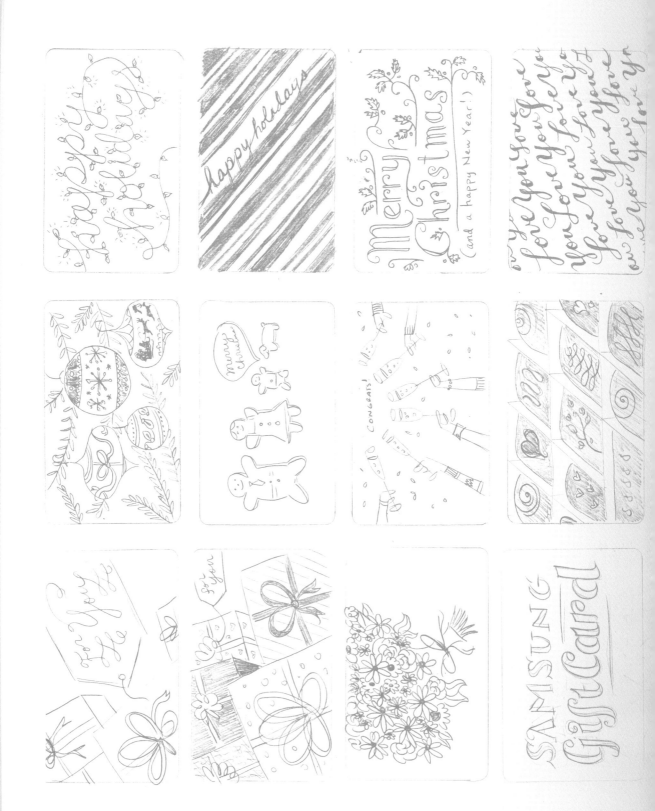

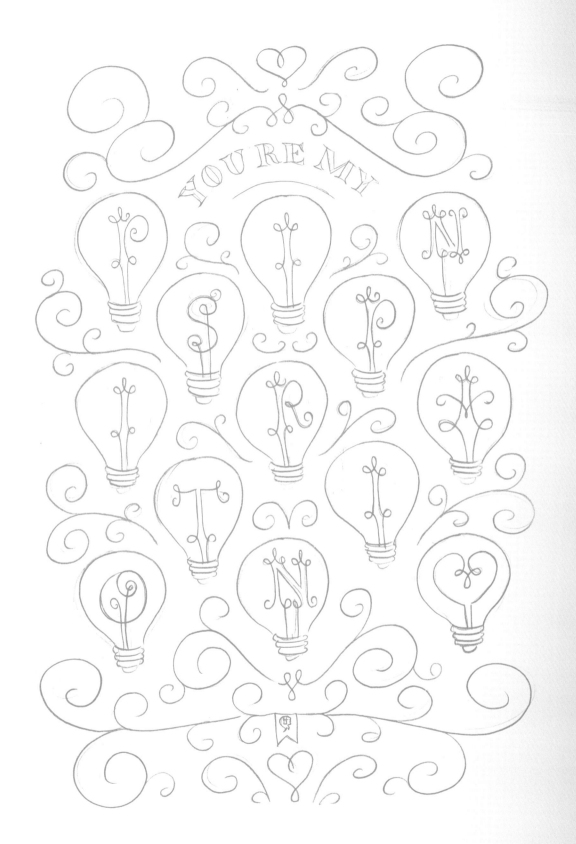

You're My Pinspiration

Client: Pinterest
Art Direction: Evan Sharp

I'm a big fan of Pinterest and have been able to befriend a lot of folks at the company since moving to the Bay Area. I am always looking for excuses to collaborate with them on projects, and Evan commissioned me to draw "You're My Pinspiration" for use on cards that users could give to the people who get their creative juices flowing. The art was foil stamped in different color combinations on really nice card stock and was also used at the Pinterest office as giant cut-vinyl wall art. The lettering and ornaments are entirely created with monoline strokes.

Focus Features and Indian Paintbrush Present an American Empirical Picture "Moonrise Kingdom"
Casting by Douglas Aibel Co-Producers Molly Cooper Lila Yacoub Costume Designer Kasia Walicka Maimone
Original Music by Alexandre Desplat Music Supervisor Randall Poster Editor Andrew Weisblum ACE
Production Designer Adam Stockhausen Director of Photography Robert Yeoman ASC Executive Producers Sam Hoffman
Mark Roybal Produced by Wes Anderson Scott Rudin Steven Rales Jeremy Dawson
Written by Wes Anderson & Roman Coppola Directed by Wes Anderson

Moonrise Kingdom

A Film by Wes Anderson

Bruce Willis

Edward Norton

Bill Murray

Frances McDormand

Tilda Swinton

Jason Schwartzman

Bob Balaban

MOONRISE
KINGDOM
NEW PENZANCE ISLAND
SUMMER
1965

PG-13 PARENTS STRONGLY CAUTIONED
SEXUAL CONTENT AND SMOKING

MoonriseKingdom.com

FOCUS
FEATURES

Moonrise Kingdom

Client: Wes Anderson

Art Direction: Wes Anderson, Jeremy Dawson, Molly Cooper

I had the honor of creating the film titles for Wes Anderson's film *Moonrise Kingdom*, working directly with Wes and his small team of coproducers to bring his vision to life. I was hired to create the twenty or so credits in the beginning of the movie and a typeface to be used in the end credits. I ended up creating two fonts—two optically weighted scripts that would feel as if they were the same weight when used at different sizes. Working with Wes was an absolute dream, and I was amazed

ABCDEFGH
IJKLMNO
PQRSTUV
WXYZ
abcdefghijklmnopqrstuvwxyz
0123456789

ABCDEFGH
IJKLMNO
PQRSTUV
WXYZ
abcdefghijklmnopqrstuvwxyz
0123456789

and impressed at just how involved he is with every aspect of his films and was blown away by his intuitive skills with typography and type design. This was a really unique project for so many reasons and it definitely got me out of my lettering comfort zone. There are no pencil sketches to show, as the upfront exploration process happened very quickly and we were starting with a reference point, but I've outlined the stages the main title went through, which then influenced the development of the rest of the project.

To the left are the main glyphs from the typefaces, and the differences between the two fonts are subtle. The large version (on top) has a lower x-height, more swashes within letterforms, tighter letter spacing, and higher contrast between the thicks and thins. The small version (on the bottom) had to be simplified so that it would read better at smaller sizes, especially in the end credits. It looks bolder here, as they're shown at a similar scale, but when the small version is scaled down appropriately, they appear to be the same weight.

The project began with Edwardian Script. The team had set all the titles but realized it was too formal for the film, plus there were worries about whether the thin typeface would work on lower-resolution screens.

Moonrise Kingdom

For the first presentation, I stuck pretty close to the source, stripping away some of the swashes to simplify the title. This still wasn't right, though, and definitely didn't help with the screen resolution issue.

Moonrise Kingdom

Next, I took the simplified script and beefed it up a bit, lowering the contrast between the thicks and thins so that it might fare better on smaller screens.

Moonrise Kingdom

I also showed a no-contrast monoline option, that was very different from the original but was a good exercise in loosening up and getting away from the inspiration source. Both options weren't quite right, so we started over.

Moonrise Kingdom

Wes and Jeremy sent over film titles from Claude Chabrol's *La Femme Infidèle* and cited how they felt more hand-done, less formal, and a step in the right direction. I started from scratch and delivered this option.

Moonrise Kingdom

The only feedback Wes had was to make the *M* have more of a looped script feel (sending over a visual example to reference) and the title was almost complete.

Moonrise Kingdom

Wes wanted to add monoline swashes to the title, which referenced Suzy's handwriting and made the title still a bit less formal. I was hesitant to defy the thick/thin logic of the letters, but in the end it did make the title a little more playful.

Moonrise Kingdom

Acknowledgments

When I set out to make this book, I had a very different vision of what it would be—I thought I would showcase my sketches and give a bit of insight into how final projects developed from start to finish...but as I began writing, it grew and grew.

What it became isn't just a book full of pretty pictures, it's a resource. It is so much more in-depth than I had originally envisioned, and every day I think of more things I wish I could have crammed into its pages. It's not a complete reference guide to everything you need to know about lettering and type, but there's no way it could be. There's already so much wonderful writing about letterform design out there, and I hope this book acts as a supplement or becomes your gateway drug into the awesome, nerdy world of the letter-obsessed.

I want to thank everyone that helped in the creation of this book, whether directly or indirectly: My parents (all six of them) for all the encouragement they've given me; Mrs. Angela Glowatch, the toughest high school art teacher the world has ever known; Carmina Cianciulli, who saw potential in my mediocre high school portfolio and who gives really excellent hugs; Joe Scorsone, Alice Drueding, Kelly Holohan, Stephanie Knopp, Paul Sheriff, Scott Laserow, Dermot MacCormack, and all unmentioned Tyler School of Art faculty who helped me fall in love with design, pushing me to work harder than I ever thought I could;

Paul Kepple, for being an amazing teacher and mentor and for crediting me as "super intern" in the back of books I worked on at Headcase; Jason Kernevich, for being an awesome influence on my life (design, music, food, booze…you name it); Louise Fili for teaching me so much—for being generous with her time, knowledge, and gelato; my rep, Frank Sturges, for being my "sanity maker" and for always making sure my calendar doesn't eat me whole; Jesse Ragan, Alexander (Sasha) Tochilovsky, and the other Type@Cooper instructors; my current and former studiomates, in particular Erik Marinovich, for providing endless helpful feedback, laughs, and rooftop beers; all the amazing art directors and clients I've had the privilege of working with over the years; all the lovely type nerds, young and less young, who have become my dear friends and are always happy to offer criticism, whether I ask them to or not; my editor, Kate Woodrow, who kept my stress levels down and helped me trim the text without shearing away all my goofy asides and idiosyncratic language; and of course Russ, my husband, for all the love, encouragement, silliness, and nerdiness he's brought to my life.

Oh, and my cats, because I'm obsessed with them.

Index

After reading this book, you probably know more about me than some of my closest friends do. But if you want to see more of my work, read my thoughts, or follow my daily exploits, visit jessicahische.is/awesome